Masterpieces
of the J. Paul Getty Museum

ANTIQUITIES

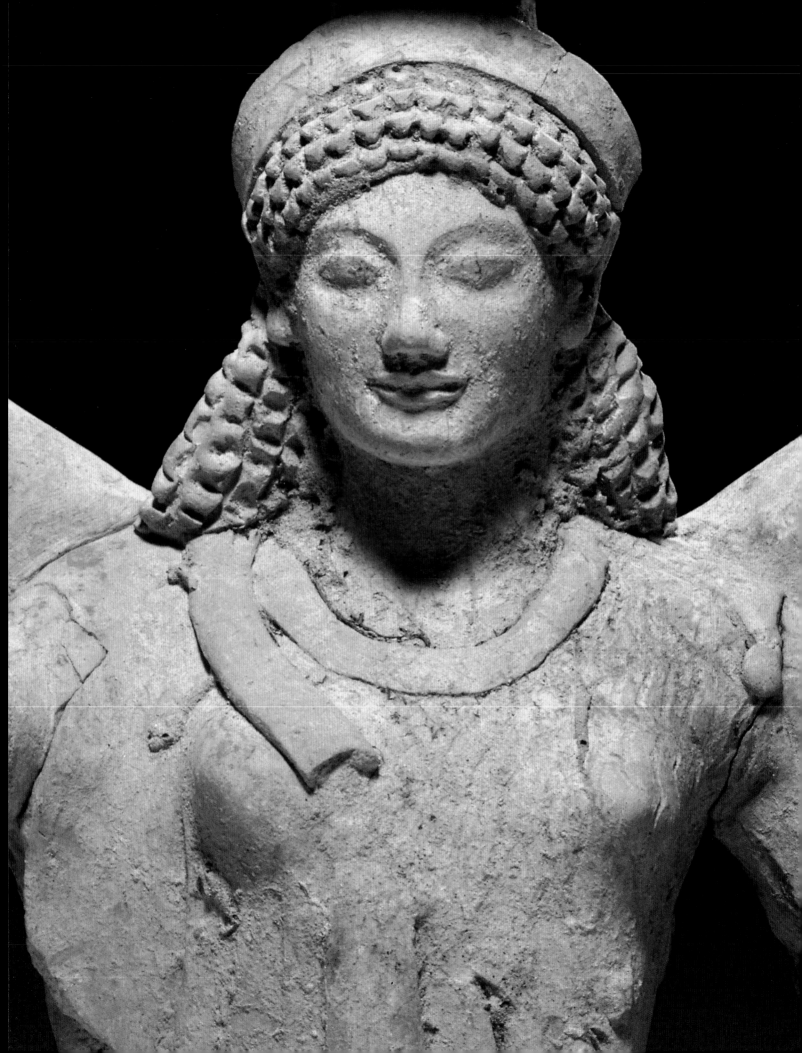

Masterpieces
of the J. Paul Getty Museum

ANTIQUITIES

Los Angeles
THE J. PAUL GETTY MUSEUM

Frontispiece:
Thymiaterion Supported
by a Statuette of Nike [detail]
South Italy (Tarentum or Sicily),
terracotta, 500–480 B.C.
86.AD.681 (See p. 79)

At the J. Paul Getty Museum:

Christopher Hudson, *Publisher*
Mark Greenberg, *Managing Editor*
Benedicte Gilman, *Editor*
Suzanne Watson Petralli, *Production Coordinator*
Ellen Rosenbery, *Photographer*

Text prepared by Elana Towne-Markus

Designed and produced by Thames and Hudson
and copublished with the J. Paul Getty Museum

Library of Congress Card Number 96-22653

ISBN 0-89236-420-3

Color reproductions by CLG Fotolito, Verona, Italy

Printed and bound in Singapore by C.S. Graphics

CONTENTS

DIRECTOR'S FOREWORD 6

THE BRONZE AGE AND GEOMETRIC PERIOD 9

ARCHAIC AND CLASSICAL PERIODS 23

HELLENISTIC PERIOD 59

ETRURIA AND SOUTH ITALY IN THE PREROMAN PERIOD 73

REPUBLICAN AND IMPERIAL ROMAN PERIODS 95

DIRECTOR'S FOREWORD

J. Paul Getty began collecting in the early 1930s, but not until 1939 did he start to buy Greek and Roman art. In the ensuing years classical antiquity seized his imagination to a degree that is rare in the history of collecting. He travelled in the archaeological countries of the Mediterranean, he read specialized literature, and he bought several villas in Italy. In 1955 he wrote the novella *Journey from Corinth* about the building of the Villa dei Papiri in Herculaneum, near ancient Neapolis (Naples), in which Getty's sketch of its rich and cultivated owner, Lucius Calpurnius Piso, resembled a self-portrait. (Less wonder that Getty later decided to reconstruct Piso's villa.) In 1957 he sent his personal collection of antiquities to the small museum he had opened three years earlier in his house in Malibu, where it made a respectable gallery. He went on buying until he died in 1976. Getty's early purchases, such as the *Herakles* from Lansdowne House and his fine group of Roman portraits, are still mainstays of the Getty Museum's collection.

The legacy J. Paul Getty left to his museum at his death in 1976, worth several hundred million dollars, made many things possible—not only the enlargement of the collection but also the creation by the Getty Trust of parallel organizations devoted to scholarship, conservation, and education in the visual arts.

Greek and Roman antiquities have retained a fundamental significance for the Getty Museum, not just because they inspired its founder to reconstruct the Villa dei Papiri in Malibu to house his collections, but also because they represent the main source of ideas and forms for so much European art in later centuries. The collection has grown dramatically in size and scope during the past fifteen years. The direction was provided by Getty's own collection and by additions made to it in the 1960s and 1970s, which were mainly stone and bronze sculpture and focused on the Western inheritance from Greece and Rome. Getty liked sculpture and glass, disliked vases, and in particular avoided objects associated with death, such as sarcophagi. There have been many acquisitions of both small- and large-scale marble, bronze, and terracotta figures. The chronology has been pushed back a millennium by examples of Bronze Age sculpture from various Mediterranean locations—the Cyclades, Cyprus, Anatolia. The few Greek and Italiote vases originally given to the Museum were greatly augmented by the acquisition of the Molly and Walter Bareiss collection of Greek vases. Under the first curator of antiquities, Jiří Frel, the collection was transformed from a group of personal holdings into a public collection: there were objects of great beauty in the galleries, and large numbers of works in the storerooms of considerable interest to specialists.

Since the appointment of Marion True as curator in 1986, the collection has grown much further. Many more sculptures and vases have been added, along with Greek and

Roman objects of luxury made of gold and silver, as well as glass and precious gems. At the same time the scope of the collection has continued to widen, bringing objects from the ancient provinces of northern Europe, Egypt, and the Near East into association with the Greco-Roman heart of the collection. With this growth the Antiquities Department has maintained an impressive program of scholarly symposia, publications, and gallery installations. For the lay public there have been lectures, theatrical performances, and family programs, all aimed at making the material accessible.

As I write, the Museum has just made the greatest acquisition of antiquities since it received Getty's own gift. Three hundred-odd works from the collection of Lawrence and Barbara Fleischman, in large part a donation, add immeasurably to the importance and the scope of the Getty's Greek, Roman, and Etruscan holdings. Most can be found in the catalogue *A Passion for Antiquities: Ancient Art from the Collection of Barbara and Lawrence Fleischman*, published by the Museum in 1994, but they were added too recently to be included here.

The text of this book was written by Elana Towne-Markus, who has my warm thanks.

When this book appears, the Villa in Malibu will have closed for the first time since it opened in 1974. Renovations to designs by the Boston firm of Machado and Silvetti will begin shortly thereafter. In the year 2001 the Villa will reopen, not just as a branch of the Getty Museum for antiquities but also as a center for comparative archaeology in which various Getty organizations will work in partnership to enrich scholarship in the field, train conservators, and educate children and a broad spectrum of the adult public. At its core will be the Getty Museum's collection of antiquities, still less than fifty years old, whose high points are the subject of this book.

JOHN WALSH
Director

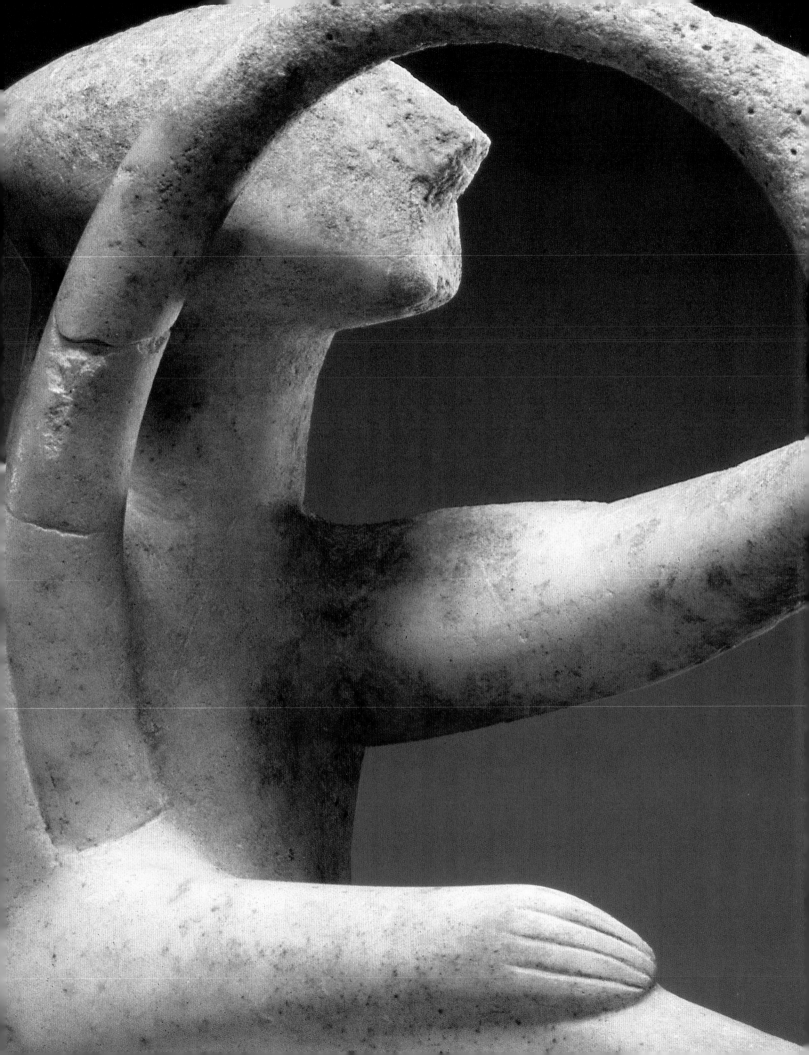

THE BRONZE AGE AND GEOMETRIC PERIOD

The Greek Bronze Age is conventionally dated to about 3000–1100 B.C. Also known as Greece's "Golden Age of Heroes," the late part of the Bronze Age is the period of Homer's *Iliad* and *Odyssey*. Various cultures flourished during this time—including the Cycladic, Minoan, and Mycenaean.

During the early Bronze Age, the Cyclades—the group of islands in the Aegean Sea that encircle the sacred island of Delos, birthplace of the deities Apollo and Artemis—were a thriving area both economically and culturally. This archipelago was the crossroads for the widespread trading that occurred throughout the eastern Mediterranean.

The inhabitants of these islands produced numerous finely carved marble statuettes of men and women. The material for the figures came from plentiful local quarries, especially those on the islands of Naxos and Paros. Some of these objects have been found in burial sites and may have served as funerary offerings, while others have been found in what appear to be sanctuaries, and their exact meaning remains unknown. The statuettes of females, who are typically portrayed with arms crossed in front of them, may represent a protective goddess, a fertility figure, or a guardian. Still visible on some of these finely carved pieces are painted details such as open eyes, hair, and possible tattooing on the face. Statuettes of men, less common, show musicians and warriors. These types of figures are found in many parts of Greece, and similar figures have been found in Anatolia and Cyprus.

Cycladic craftsmen also produced a variety of marble and terracotta vessels. These vases are finely crafted, often with closely fitting lids. Some preserve traces of pigments on the interiors. They, too, have been found in graves.

Minoan and mainland Greek culture began to exert a strong influence on the Cyclades around 1700 B.C. The earliest influences spread from the Aegean island of Crete, where the Minoan civilization was the predominant culture from about 2000 B.C. to 1400 B.C. Named after the legendary king Minos, the Minoan civilization was characterized by urban population centers gathered around large architectural complexes, the so-called palaces, which were central administration sites. These expansive unfortified structures were decorated with beautiful frescoes depicting aspects of Minoan daily life and customs and incorporating local and mythical animal, sea, and plant life. The structures also seem to have functioned as economic centers, which held large reserves of produce in the lower storerooms. The British scholar Sir Arthur Evans, who in the early twentieth century excavated the largest and most important of the Minoan palaces, at Knossos in central Crete, uncovered numerous objects such as jewelry, statuettes, vases, and other artifacts throughout the complex. The Minoans

had a system of writing known as Linear A, which remains undeciphered, and much of Minoan culture is therefore unknown to us.

By the sixteenth century B.C., another society was developing on the Greek mainland. The Mycenaeans, or Achaians, as Homer called them, are named after the city of Mycenae on the edge of the Plain of Argos in the Peloponnese. In contrast to the large, open palatial complexes of the Minoans, the Mycenaeans built heavily fortified citadels in high places. The German archaeologist Heinrich Schliemann excavated much of the city of Mycenae in the late nineteenth century. While excavations have uncovered many artifacts that provide insight into Mycenaean culture, the decipherment of their script, an early form of Greek known as Linear B, gives us a better understanding of aspects of Mycenaean daily life, especially financial transactions and the central administration of Mycenaean palaces by a ruler. Like the Minoans, the Mycenaeans enjoyed extensive commercial relations with Egypt, Cyprus, the Near East, and the western Mediterranean. Their buildings were decorated with frescoes that show a striking similarity to those of the Minoans, from whom they apparently learned this art. Mycenaean paintings differ from the preserved Minoan ones in their iconography in that scenes of hunting and warfare are more common. Similar images are also painted on the surfaces of their vases. The Mycenaean civilization came to an end either at the hands of outside invaders or because of internal collapse sometime between 1200 and 1100 B.C.

The period immediately following the collapse of the Bronze Age palaces is one of the least understood in Greek history. Often described as a "Dark Age," it was marked, on the one hand, by a serious decline in culture, with the virtual disappearance of monumental architecture, anthropomorphic art, and writing, while, on the other hand, it was ushered in by an important technological innovation—the widespread use of iron. Artistic production included pottery and small stylized figurines. By the ninth century B.C., Greece entered an artistic period known as the Geometric, named after the geometric designs that form the basis of ceramic decoration. Political life, centered around a series of *poleis,* or city-states, replaced the centralized monarchical system of the Bronze Age. Each *polis* established its own legal and economic system and formed its own army. The Geometric period, which witnessed the reemergence of monumental art in the form of large vases, was also the period in which athletic games at Olympia were established, traditionally dated to the year 776 B.C. The later Geometric period saw a growth in prosperity, population, and trade between lands in the eastern and western Mediterranean. During the later eighth century B.C., many Greek colonies were founded in Sicily and South Italy—the area known as Magna Graecia—followed

by colonies on the Black Sea. During this time, the Greeks adopted and adapted the Phoenician alphabet to form a script of their own, and it is to this period that the earliest written Greek poems are assigned.

Not only were vases used for various everyday activities during the Geometric period, but they also sometimes served a funerary function as cinerary urns and grave markers. In addition to vases, solid-cast bronze and terracotta statuettes were produced. These included animal and human representations incorporating basic geometric forms to create the image. Abstract geometric forms, such as meander patterns and concentric circles, were the basis of decoration, instead of the more naturalistic floral and marine life of the Bronze Age. During the eighth century B.C., stylized figural motifs were added to these abstract forms. Various techniques, styles, and motifs were adopted from the eastern world, including such mythical beings as the griffin, a hybrid creature that combined features from a lion, a bird, and a snake. Figural representations gradually expanded to cover more of the surface of the vase than the geometric motifs. Gradually, during the course of the eighth century B.C., the human figure regained its importance in artistic representation as Greek art moved into the early Archaic period.

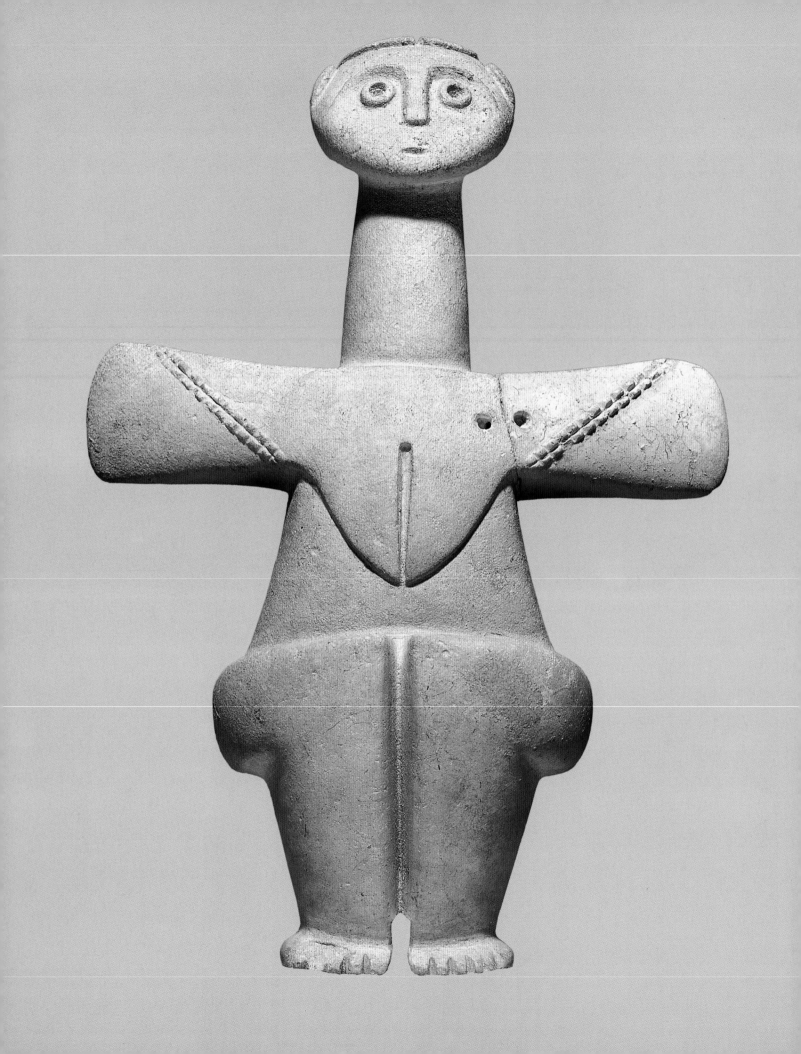

Fertility Goddess
Cyprus, limestone, 3000–2500 B.C.

Height: 42.4 cm (16½ in.)
Width: 27.7 cm (10¹³⁄₁₆ in.)
83.AA.38

Female Idol of the Kilia Type ("Stargazer")
Anatolia, marble, 2700–2400 B.C.

Height: 14.2 cm (5⁹⁄₁₆ in.)
88.AA.122

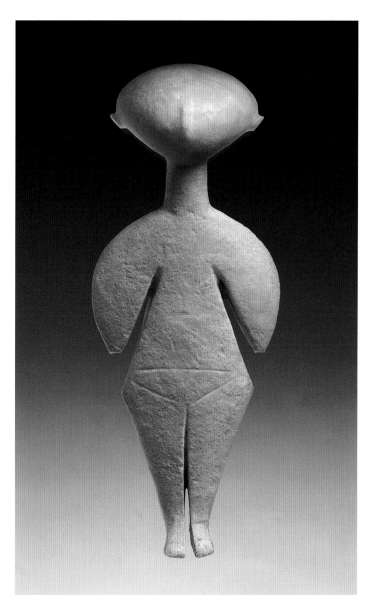

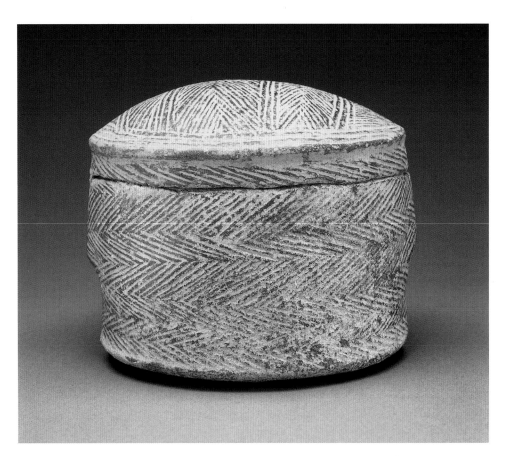

Cycladic Terracotta

Cylindrical Pyxis and Cover
of the Pelos Group,
3000–2800 B.C.

Height: 13.2 cm (5⅛ in.)
Diameter: 14 cm (5½ in.)
91.AE.30

Collared Jar of the Pelos Group,
3000–2800 B.C.

Height: 14.8 cm (5¾ in.)
Diameter: 14.6 cm (5¹¹⁄₁₆ in.)
91.AE.29

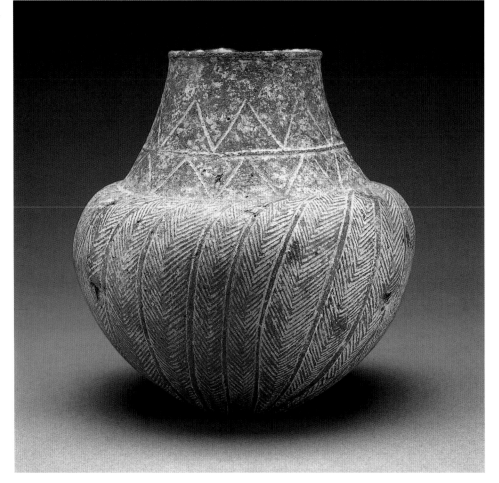

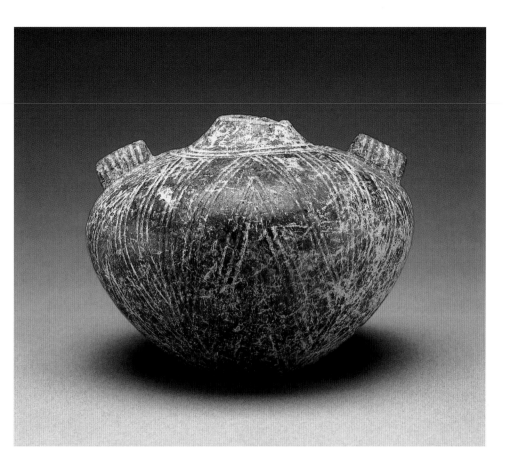

Bottle of the Kampos Style,
2800–2700 B.C.

Height: 9.7 cm (3¹³⁄₁₆ in.)
Diameter: 12.7 cm (4¹⁵⁄₁₆ in.)
91.AE.28

Double Kandila,
3000–2800 B.C.

Height: 10.1 cm (4 in.)
Diameter: 8.9 cm (3½ in.)
91.AE.31

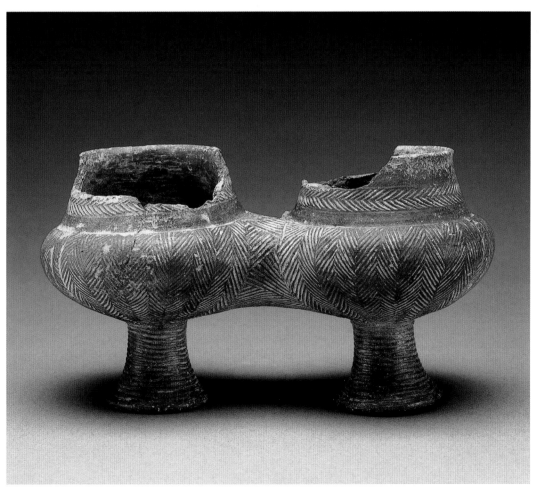

Harpist
Cyclades, island marble,
about 2500 B.C.

Height: 35.8 cm (14 in.)
Width: 9.5 cm (3¹¹⁄₁₆ in.)
85.AA.103

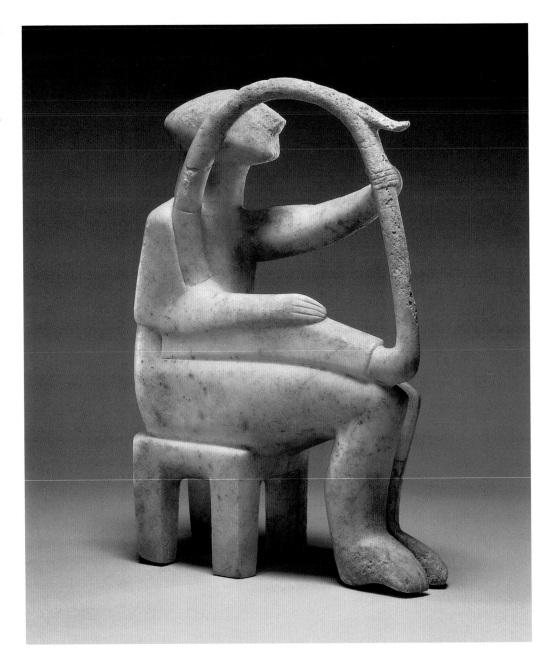

Reclining Female Figure of the Late Spedos Variety
Cyclades, island marble,
2500–2400 B.C.

Height: 59.9 cm (23⅜ in.)
88.AA.80

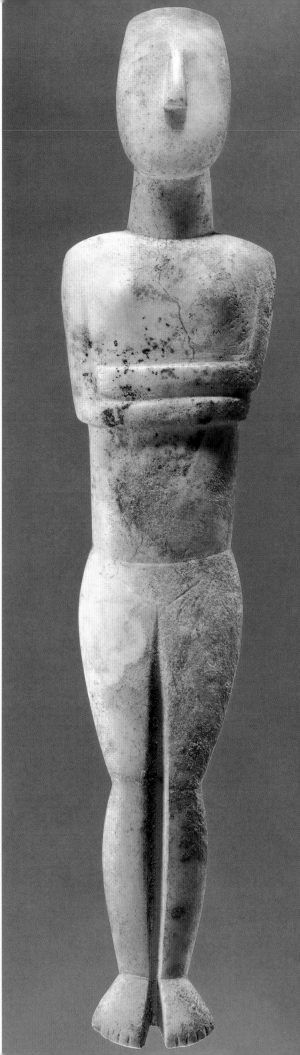

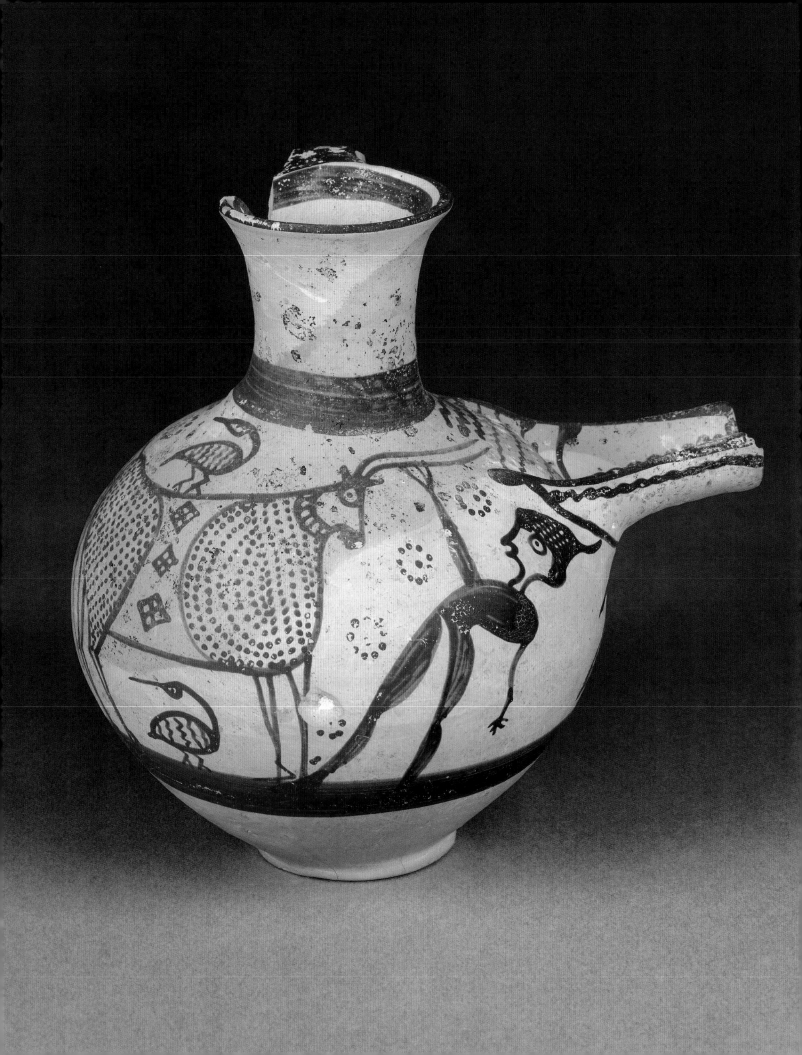

Mycenaean Sieve Jug with a Continuous
Frieze of Figures—Sphinx, Bull with a Bird
on Its Back, a Man Grasping the Bull's Horn
Cyprus or Greece (?), terracotta,
1250–1225 B.C.

Height: 16.6 cm (6½ in.)
Diameter (body): 13 cm (5⅟₁₆ in.)
Attributed to Painter 20
85.AE.145

Geometric Statuette of a Horse
Greece, bronze, 800–600 B.C.

Height: 7.9 cm (3⅟₁₆ in.)
85.AB.445

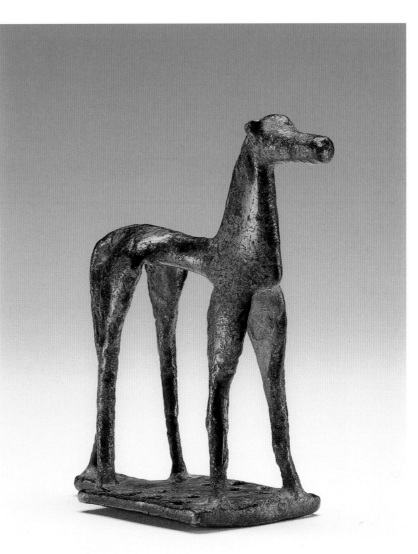

Late Geometric Attic Cup with Grazing Deer and Birds
Athens, terracotta, about 730 B.C.

Height: 6 cm (2⅜ in.)
Diameter: 16.3 cm (6⅜ in.)
79.AE.117

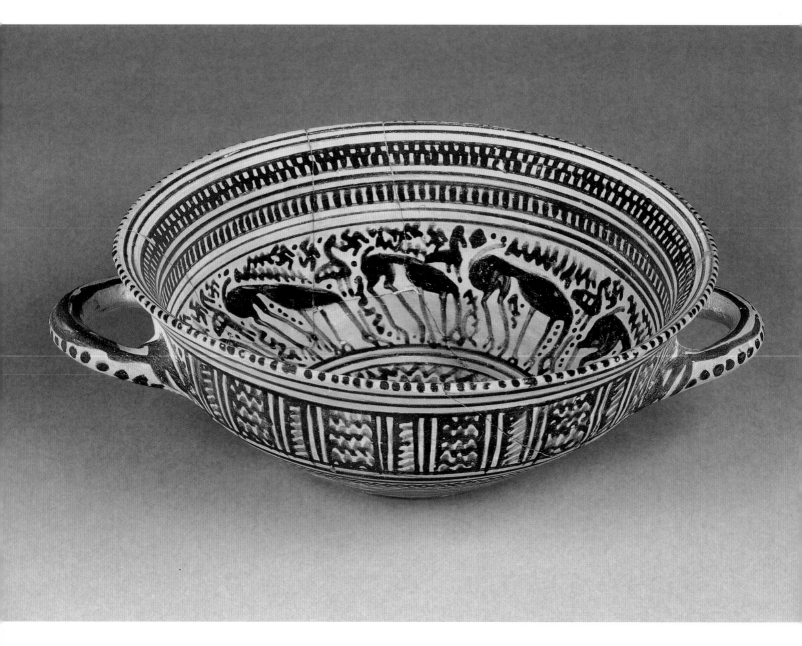

Statuette of a Lyre Player
with a Companion
Greece, bronze, seventh century B.C.

Height: 11.5 cm (4½ in.)
90.AB.6

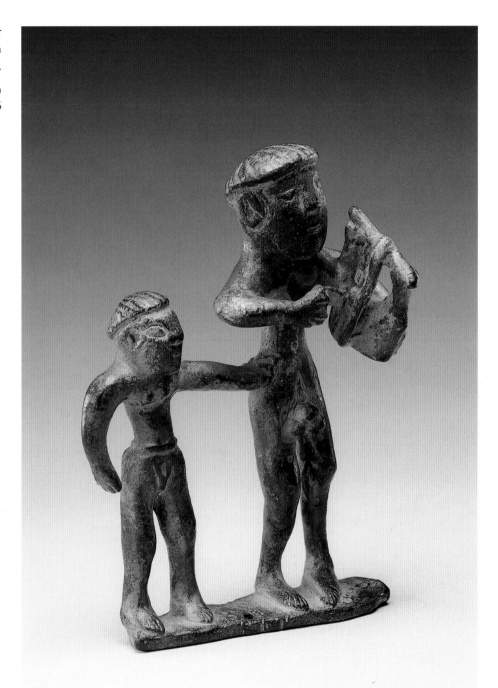

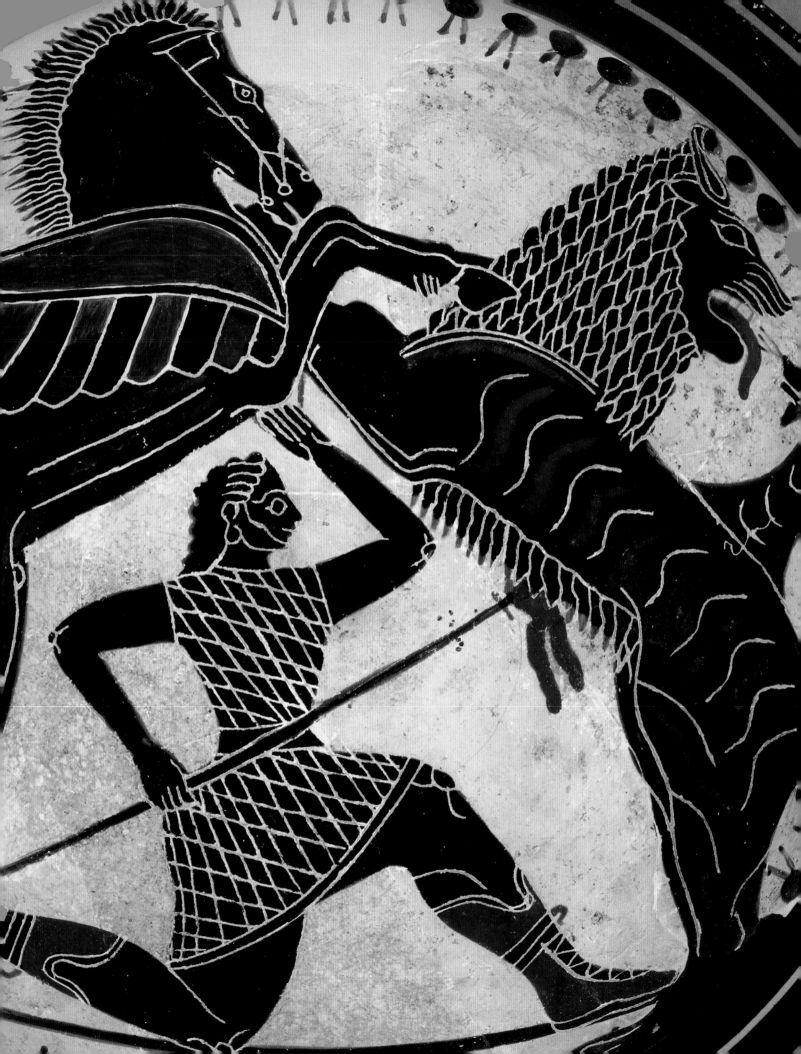

ARCHAIC AND CLASSICAL PERIODS

The period from about 650 to about 480 B.C. in the Greek world is known as the Archaic. It was a time of growing population and wealth. Although the city-states remained independent, there was an increasing sense of Greek national identity among the various *poleis,* who united against the "other," which included all non-Greeks, especially the Persians. The growth in wealth encouraged expansion of trade throughout the Mediterranean with peoples such as the Carthaginians, Egyptians, Persians, and Etruscans.

Religion was one of the major sources of inspiration for Archaic art. Numerous temples, statues of deities, and votive offerings were commissioned to please, honor, persuade, or thank the gods. To this end, the Greeks drew from a repertory of mythological figures and heroes of the past, such as Amazons, Centaurs, and the Olympian deities, as well as figures from the Trojan War. Artists relied upon a number of fixed artistic approaches to the representation of humans, fantastic creatures such as griffins and Centaurs, and stylized plant forms to decorate their temples, vases, and sculpture. Stylistically, Archaic art is characterized by frontal forms or straight profiles and by symmetry, repetition, and geometric abstractions.

The architecture of the Archaic period was greatly influenced by the Egyptians, who produced monumental stone architecture with columns that have carved capitals and bases. Before the Archaic period, the Greeks built fairly simple temples of stone, wood, or brick without much sculptural decoration. From the middle of the seventh century B.C. onward, however, Greek temples were of post-and-lintel construction. Typically, a row of columns with decorated capitals framed the four sides of the *cella,* the room where the cult statue was housed. Religious events were for the most part carried out at the altar that was placed in front of the temple, which was usually oriented with the entrance at the east end. The colonnade surrounding the *cella* supported the horizontal entablature and pitched roof. The pediments in the gables and the horizontal frieze above the columns were decorated with sculpture. Two architectural orders of columns were developed during the Archaic period—Doric and Ionic. They were not restricted in use to temples but were often incorporated into other buildings, such as treasuries and *stoas,* the all-purpose building of the Greeks.

Life-size freestanding statues in marble or other stone were widely produced during this time. The most common type is called a *kouros,* or male youth. The Greeks also sculpted statues of females, known by the Greek word for young woman, *kore. Kouroi* and *korai* are typically idealized figures placed in a frontal pose, the left foot advanced with the weight placed between the two feet, and the arms held rigidly at the sides or extended to hold a *patera,* a shallow bowl used for sacrificial libations. Surface

patterning and geometric forms used to describe human anatomy were at first incised into the stone and later modeled more naturalistically. The female figures are portrayed as clothed, while the males are generally nude, emphasizing the Greek belief that outer beauty was a sign of inner beauty. Paint would have been added to the hair, face, and clothing. Both these subjects display a debt to Egyptian sculpture, which was likewise frontal, rigid, and very patterned, and to which the Greeks had had access since the mid-seventh century B.C. These statues served as funerary markers, monuments, and votive offerings. In addition to life-size statues and architectural sculpture, Archaic Greek sculptors made many figurines in bronze and terracotta.

Archaic vases show a continuous development from those made during the Geometric period, in shapes, styles, and decorative motifs. Greek artists continued to incorporate such Eastern motifs as the sphinx, lion, lotus, and palmette. Among the more popular shapes of vases produced during this period were the *hydria* (a water jug), the *kylix* (a drinking cup), the *aryballos* (a flask for holding perfume), the *amphora* (a storage jar), and the *krater* (a large vessel for mixing wine with water).

In the seventh century B.C., Corinthian vase painters refined a technique of decoration in which figures are painted in black silhouette with incised details against a pale background of clay, allowing for intricate scenes with multiple figures and expressive lines, which incorporated elements of narrative. Artists within Attica copied and refined this so-called black-figure technique, and by the end of the Archaic period, Attic vases dominated the export market. The geometric and floral decorative motifs that had been widely used in the Geometric period continued to adorn vases, but they were relegated to the less important parts of the vase, such as the shoulder, neck, and base, with figural scenes taking up greater, central areas.

In general, Athenian artists were interested in reproducing all the important details of a figure in order to convey it most vividly, even if that contradicted the single viewpoint. This is evident, for example, when an artist painted a profile face and included a frontal view of the eye. The black-figure technique had its limitations in that figures had to be flattened out so that their silhouette was readable. Furthermore, the depiction of depth was limited to overlapping, for the black-figure technique did not allow for foreshortening.

The red-figure technique, which was introduced in Athens about 530 B.C., allowed for greater freedom of representation. In this technique the figures are "reserved," that is, left unpainted so that the natural reddish color of the vase surface stands out against the background, which is painted black. Instead of depicting details of figures by incisions into the vase surface, artists who worked in the red-figure technique used

added black lines; sometimes the color was diluted to produce softer effects and different types of detailing.

The two techniques of decorating pottery, black- and red-figure, coexisted until about 480 B.C., after which the more restrictive black-figure technique was limited to Panathenaic amphorae. Filled with olive oil from the sacred grove of Athena, these special vases were given to victors at the Panathenaic games. The scheme of decoration of Panathenaic amphorae, showing the goddess Athena on one side and the athletic contest for which the vase was a prize on the other, was established in the sixth century B.C. and continued unchanged until the end of their production, in the second century B.C.

The pride with which potters and painters made their vases, as well as their increased social position, are apparent in the mid-sixth century B.C. when they began sometimes signing their vases. Attic vases are an important primary source of information about the ancient Greek world, especially its mythology. While Attic vases reached the highest level of refinement, numerous other areas within the Greek world produced pottery that reflects a distinct regional style, such as Rhodes in eastern Greece, Lakonia in the Peloponnese, Chalcis on Euboea, and Caere, a city in Etruria whose population included artists from eastern Greece.

The end of the Archaic period in the early fifth century B.C. was partly a result of external events, such as the Persian Wars. The conflict between the Greeks and Persians reached a zenith in 480/479 B.C. when Athens was sacked by the Persians. This destroyed many of the Archaic works of art in the city. Fortunately, much of the damaged sculpture was buried after the wars as a sign of respect, thus preserving it until its rediscovery in the nineteenth century. In order to protect themselves against the Persians, the Greeks formed the Delian League in 478 B.C., with Athens as its leader. To this confederacy the city-states paid money in exchange for protection in the form of hoplites—the heavily armed infantry—ships, and weapons. Through the Delian League, Athens protected the city-states while at the same time seeking to gain control of a number of them on the mainland—Boeotia, Megara, and Euboea. In 454 B.C., the treasury of the Delian League was moved from Delos to Athens, thereby further establishing Athens as the main power in Greece and as a cosmopolitan center for the arts as well as politics.

With a secure financial base established by the Delian League and with the victory over the Persians, the Greeks' self-confidence grew and led to an increase in large-scale artistic and architectural endeavors. The Classical period (about 480 to 323 B.C.), called the "Golden Age," was a time when other arts and sciences also thrived: it was the age of the playwrights Aeschylus, Euripides, and Aristophanes; of the philosophers Sophocles and Plato; and of the orator Demosthenes.

The most famous Classical architectural site is that of the sacred Athenian Acropolis, whose original buildings were destroyed by the Persians. Under the direction of the Athenian statesman Pericles, the Parthenon, Erectheum, Propylaea, and Temple of Athena Nike were constructed during the second half of the fifth century B.C. All of these structures were adorned with elaborate sculptural decoration. Conceived by the architect and sculptor Phidias, the Parthenon was dedicated to Athena, the patron goddess of Athens. Its decorative scheme and elegant structure embodied the virtues that the Greeks espoused, such as *arete,* moral character, and *sophrosyne,* self-restraint.

As an architectural innovation in the Classical period, Corinthian columns were introduced. The first Corinthian column, with its highly decorated capital of acanthus leaves, was placed in the interior of the Temple of Apollo Epikourios at Bassae (420 B.C.) where it served a purely decorative function. Later in the Classical period, the Corinthian order came into its own as a distinct architectural style, like the Doric and Ionic.

After mastering the representation of the idealized human figure as a naturalistic whole form, artists proceeded to attempt to represent motion and its effect on drapery and the human body in a realistic manner. One of the foremost artists of the Classical period, who wrote a treatise on how to represent the human figure as a unified whole existing in three-dimensional space, was Polykleitos. His canon of proportions dictated how each part of the body should be related proportionally to other parts. His ideas are visualized in his sculpture of a youth holding a spear, the *Doryphoros.* In the later Classical period, the artist Lysippos refined this canon of proportions by creating statues that reproduced the human figure as it appeared in real life, not necessarily how it really existed in a mathematical sense. This yielded figures that were slimmer and taller, with heads that were smaller in relation to the body. The first statue of a female nude, the Aphrodite of Knidos by Praxiteles, was made during this period, and the sculptor Skopas created images that embody a great deal of emotion, thus challenging the earlier belief that art's only subject was the idealized human without emotion. By means of images such as sunken eyes and furrowed brows, Skopas strove to capture different aspects of human life. This interest would have a great effect on the art of the following, Hellenistic period.

Like sculpture, vases continued to be produced during the Classical period, and toward the end of the fifth century they were frequently decorated with depictions of all aspects of daily life. About 460 B.C., another type of vase painting gained popularity in Attica. The white-ground technique, usually applied to *lekythoi* (vases for oil or wine used in funerary rites), allowed for greater freedom of representation, as the clay was

covered with a white slip on which images were painted in various colors. This technique is evidence of the close relationship between vase and wall painting.

Greece entered another lengthy war in 431 B.C. Unlike the earlier Persian War, the Peloponnesian War pitted Greek city-states against one another, particularly Athens against Sparta. In addition, the Greek people were struck with a plague in 430–427 B.C. The end of the Peloponnesian War in 404 B.C. witnessed the defeat of Athens and the eventual transfer of power to the Macedonian state in the northern part of Greece. The effect of the dual tragedies of war and plague is seen in the increased production of grave stelae in Athens, in the more humanistic representation of deities, and in the increase of domestic subjects.

By the middle of the fourth century B.C., all of Greece was faced with a new ruler in a new center of power, Philip II of Macedon. Philip died in 336 B.C. and was succeeded by his son, Alexander the Great. After taking control of mainland Greece, Alexander extended the boundaries of the Macedonian Empire to the furthest point ever in Greek history—east to the Indus, north to southern Russia, and south to Egypt. Alexander's power was contained by Carthage and Rome. The Classical period ended in 323 B.C. when Alexander the Great died and his empire was split among several of his generals, who created their own smaller empires centered in Macedon, Pergamon, Antioch, and Alexandria.

Olpe with Four Registers of Animals on the Body
Corinth, terracotta, 650–625 B.C.

Height: 32.8 cm (12¹³⁄₁₆ in.)
Diameter (body): 17 cm (6⅝ in.)
Attributed to the Painter of Vatican 73
85.AE.89

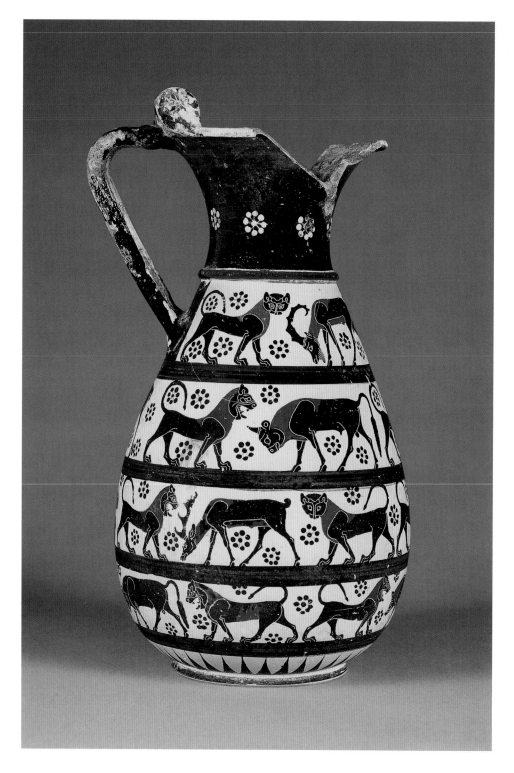

Oinochoe with Friezes of Animals
Rhodes, terracotta, about 625 B.C.

Height: 35.7 cm (14 in.)
Diameter (body): 26.5 cm (10 7/16 in.)
81.AE.83

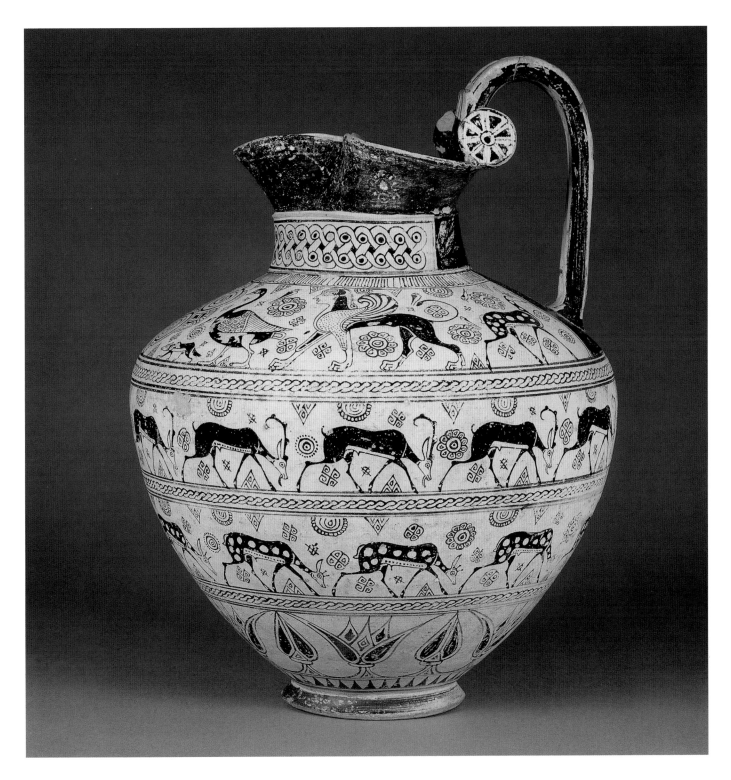

Shield Strap Fragment Showing the Abduction of
Helen and the Abduction of Deianeira
Argos, bronze, early sixth century B.C.

Height: 16.2 cm (6⁵⁄₁₆ in.)
Width: 8 cm (3⅛ in.)
Signed by Aristodamos of Argos
84.AC.11

Furniture Support Cast in the Shape
of a Winged Feline
Spain (Tartessos), bronze with gilding,
seventh to early sixth century B.C.

Height: 61 cm (23¹³⁄₁₆ in.)
79.AC.140

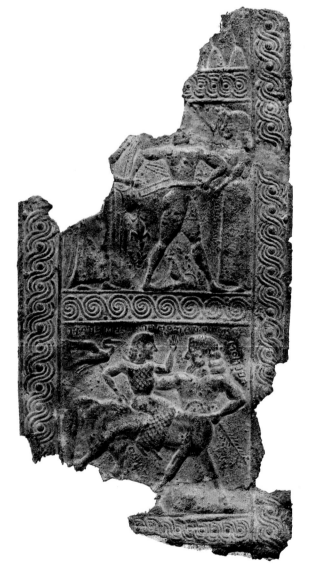

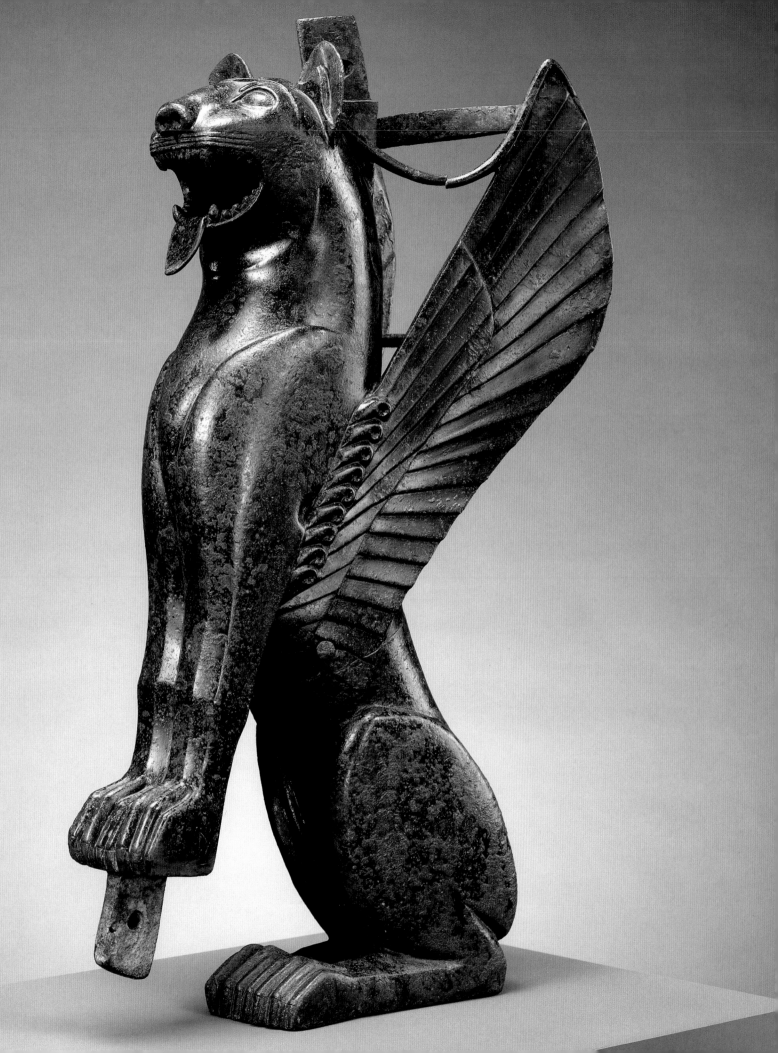

Round-Bodied Head-Pyxis with a Frieze of Animals
Corinth, terracotta, about 570 B.C.

Height: 21.8 cm (8⁹⁄₁₆ in.)
Diameter: 22.2 cm (8⁵⁄₈ in.)
Perhaps by the Chimaera Painter
88.AE.105

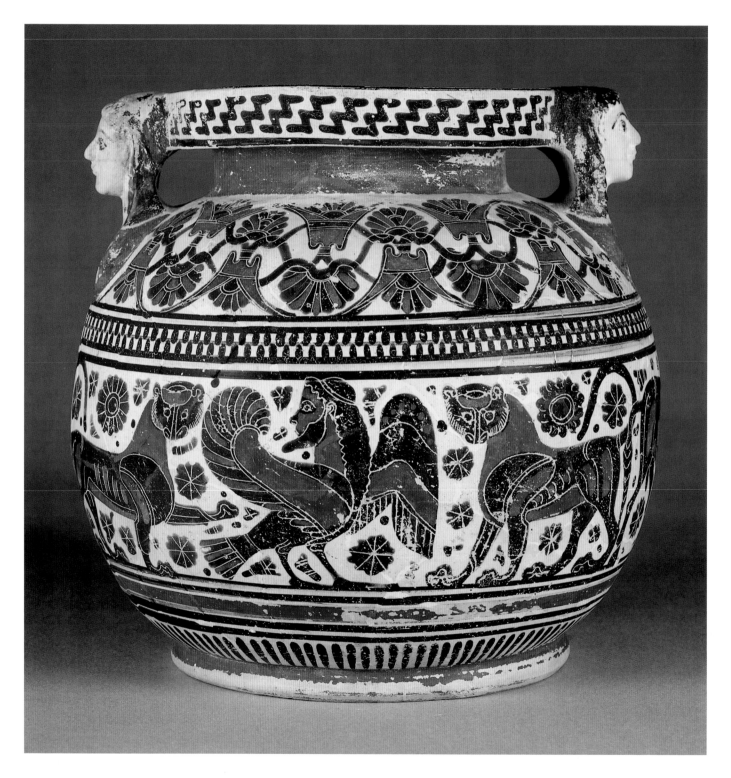

Aryballos Showing Herakles Battling the
Hydra, with Athena behind Herakles
and Iolaos behind the Hydra
Corinth, terracotta, first quarter of
sixth century B.C.

Height: 11.2 cm (4⅜ in.)
Width: 11.7 cm (4⁹⁄₁₆ in.)
92.AE.4

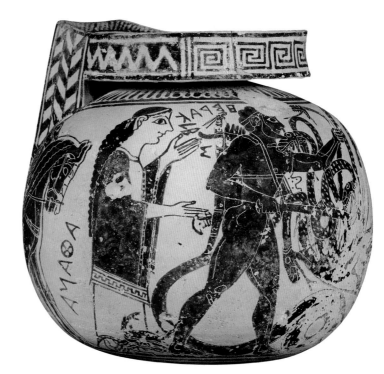

Lakonian Black-Figured Kylix
Interior: Bellerophon with Pegasos
Killing the Chimaera
Sparta, terracotta, 570–565 B.C.

Height: 12 cm (4¹¹⁄₁₆ in.)
Diameter (bowl): 14 cm (5½ in.)
Attributed to the Boread Painter
85.AE.121

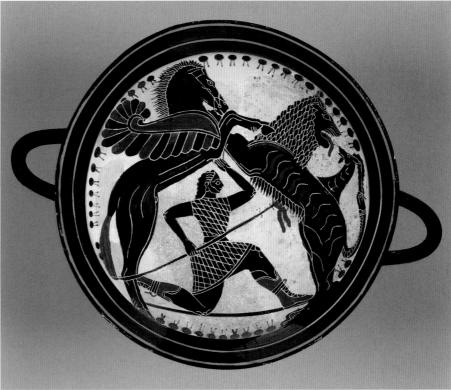

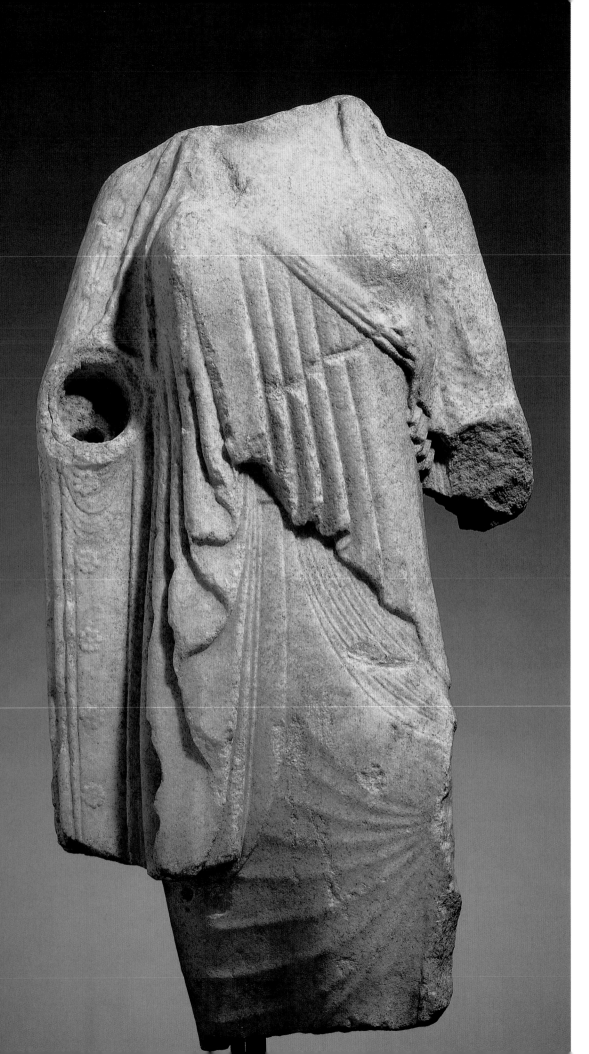

Fragmentary Statue of a Kore
Greece, Parian marble,
about 530 B.C.

Height: 73 cm (28½ in.)
Width: 41 cm (16 in.)
93.AA.24

Attic Black-Figured Type A Zone Cup
Interior: Six Symposiasts Reclining around Gorgoneion
Exterior: Herakles and Dionysos (side A); Herakles and Triton (side B)
Athens, terracotta, about 520 B.C.

Height (rim): 13.6 cm (5⁵⁄₁₆ in.)
Diameter (bowl): 36.4 cm (14³⁄₁₆ in.)
Attributed to the Manner of the
Lysippides Painter (as painter)
and to Andokides (as potter)
87.AE.22

Attic Red-Figured Kylix
Interior: Courtship Scene
Exterior: Males Exercising (side A); Youths Exercising (side B)
Athens, terracotta, 515–510 B.C.

Height: 11 cm (4¼ in.)
Diameter: 33.5 cm (13¹⁄₁₆ in.)
Attributed to the Carpenter Painter
85.AE.25

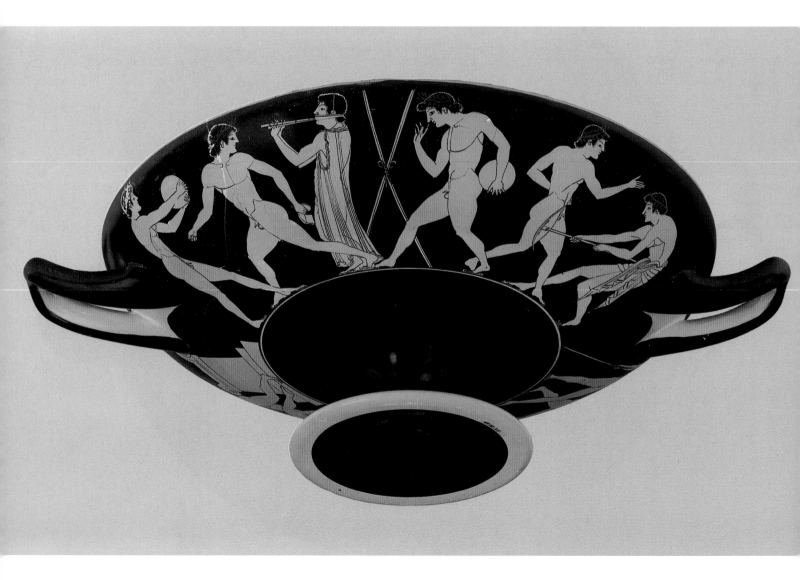

Attic White-Ground Lekythos Showing Two Warriors Arming,
Attended by a Youth and a Female
Athens, terracotta, about 500 B.C.

Height: 33.5 cm (13¹⁄₁₆ in.)
Diameter (shoulder): 12.6 cm (4⁵⁄₁₆ in.)
Attributed to Douris (as painter)
84.AE.770

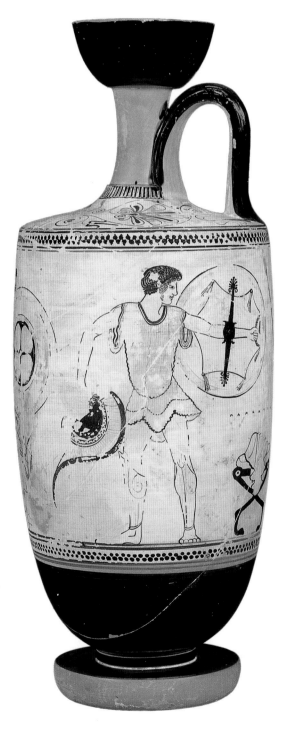

Attic Red-Figured Kylix Type C
Interior: Iliupersis (Sack of Troy)
Exterior: Briseis Being Led away from Achilles (side A);
Duel between Hector and Ajax, with Apollo and Athena (side B)
Athens, terracotta, 500–490 B.C.

Height: 19 cm (7⅜ in.)
Diameter: 46.6 cm (18³⁄₁₆ in.)
Attributed to Onesimos (as painter); signed by Euphronios (as potter)
83.AE.362

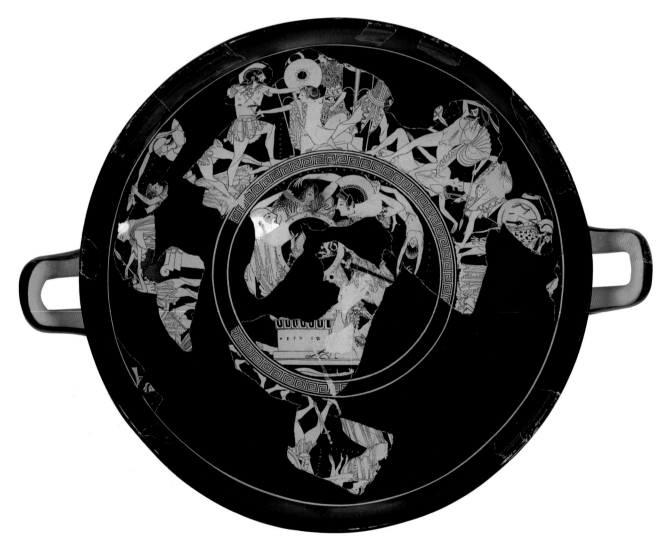

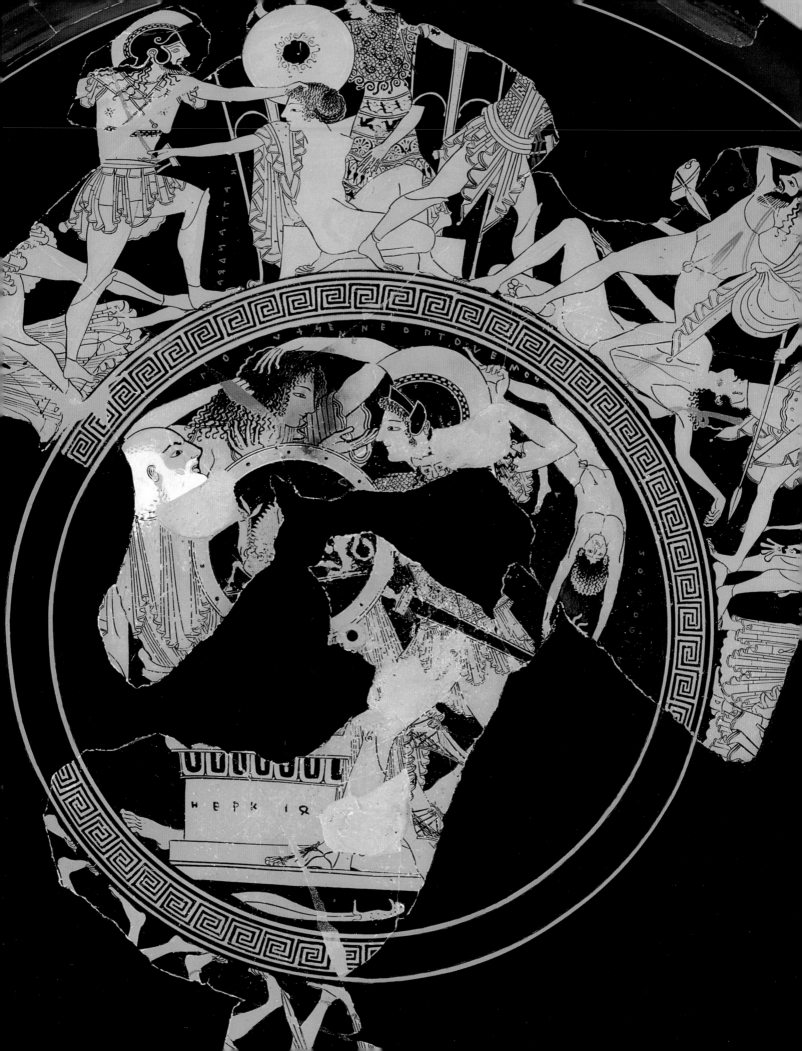

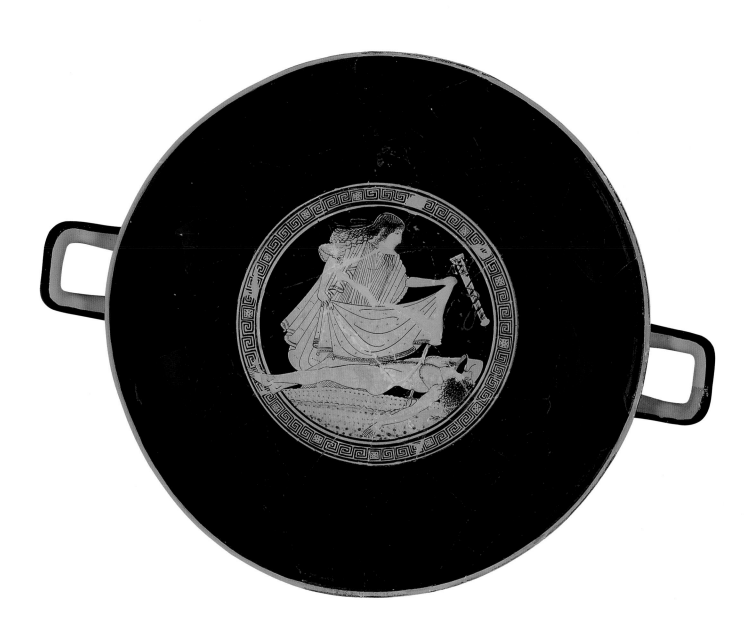

Attic Red-Figured Cup Type B
Interior: Tekmessa Covering the Body of Ajax
Exterior: Argument between Odysseus and Ajax over the Arms of Achilles (side A);
Casting of Votes to Award Achilles' Arms (side B)
Athens, terracotta, 490–480 B.C.

Height: 11.2 cm (4⅜ in.)
Diameter: 31.4 cm (12¼ in.)
Attributed to the Brygos Painter
86.AE.286

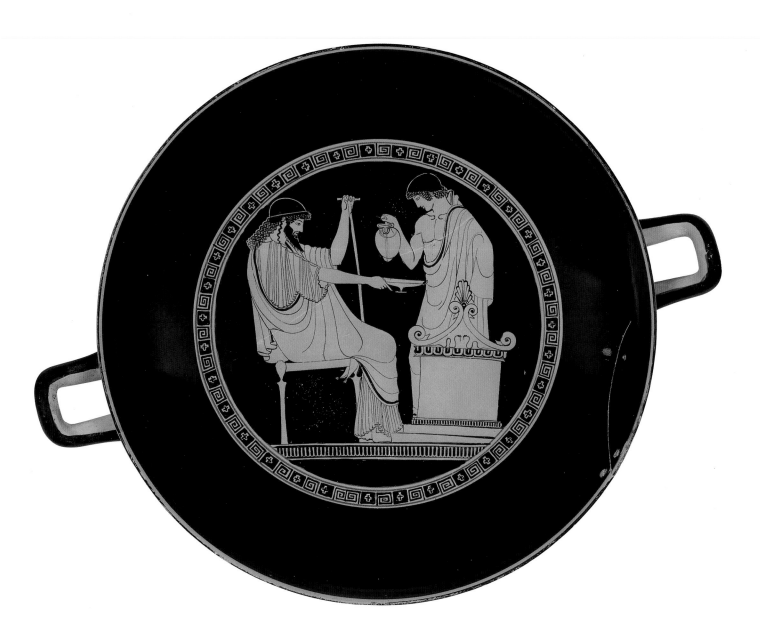

Attic Red-Figured Kylix
Interior: Zeus Served by Ganymede
Exterior: Eos Pursuing Kephalos (side A); Zeus Pursuing Ganymede (side B)
Athens, terracotta, about 480 B.C.

Height: 13.3 cm (5³⁄₁₆ in.)
Diameter: 32.4 cm (12⅝ in.)
Signed by Douris (as painter); attributed to Python (as potter)
84.AE.569

Attic Red-Figured Kantharos with Masks
Athens, terracotta, about 480 B.C.

Height (handles): 21.1 cm (8¼ in.)
Diameter (bowl): 17.4 cm (6¹³⁄₁₆ in.)
Attributed to the Foundry Painter (as painter) and to Euphronios (as potter)
85.AE.263

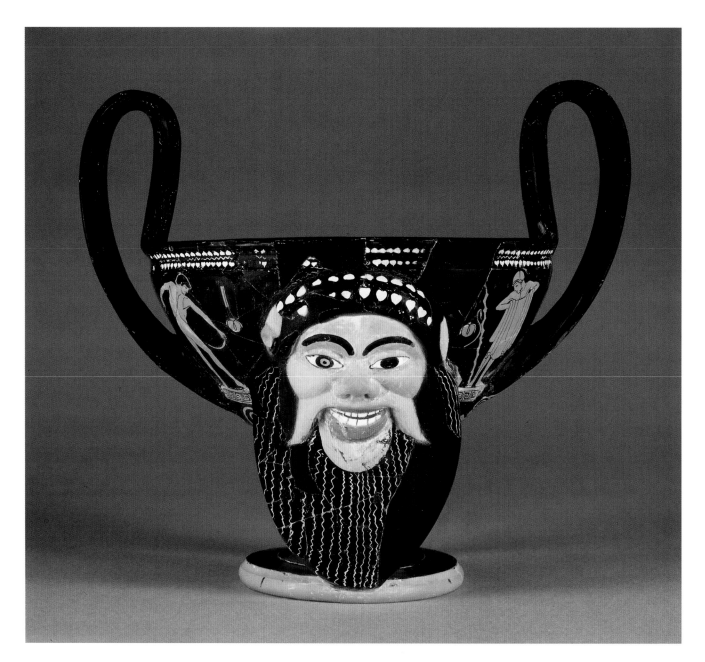

Statuette of a Satyr
Greece, bronze, 480–460 B.C.

Height: 10 cm (3⅞ in.)
Width: 4.3 cm (1⅝ in.)
88.AB.72

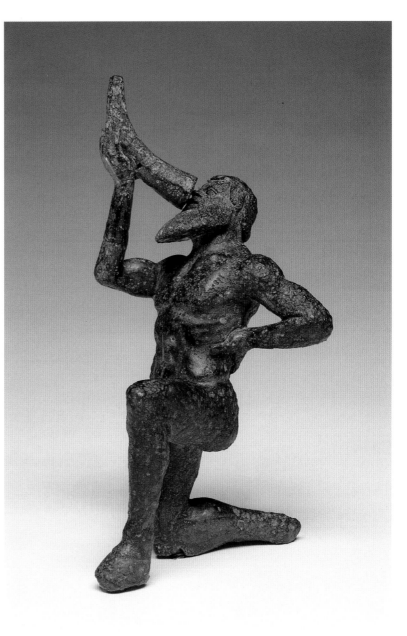

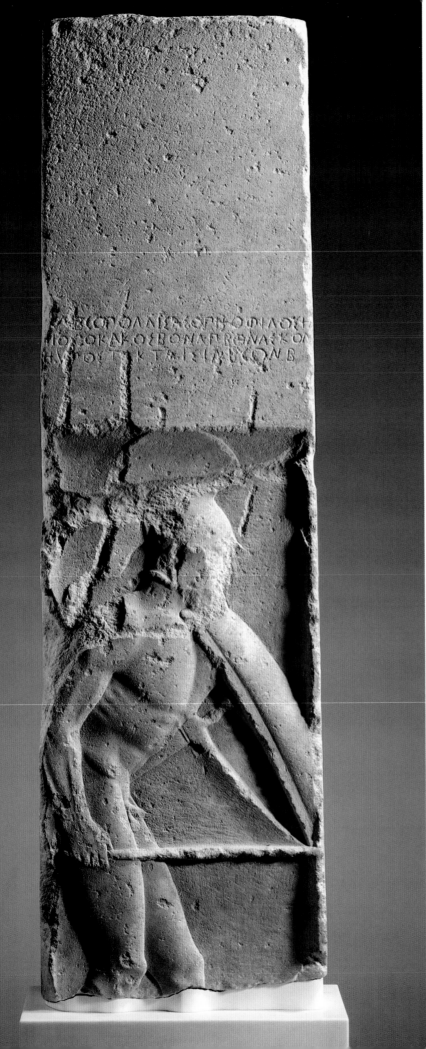

Grave Stela of the Hoplite Pollis
Megara, marble, about 480 B.C.

Height: 149.8 cm (58⁷⁄₁₆ in.)
Width: 44.5 cm (17³⁄₈ in.)
90.AA.129

Statuette of a Fallen Youth
Greece, bronze with copper inlays, 480–460 B.C.

Width: 7.3 cm (2⅞ in.)
Length: 13.5 cm (5¼ in.)
86.AB.530

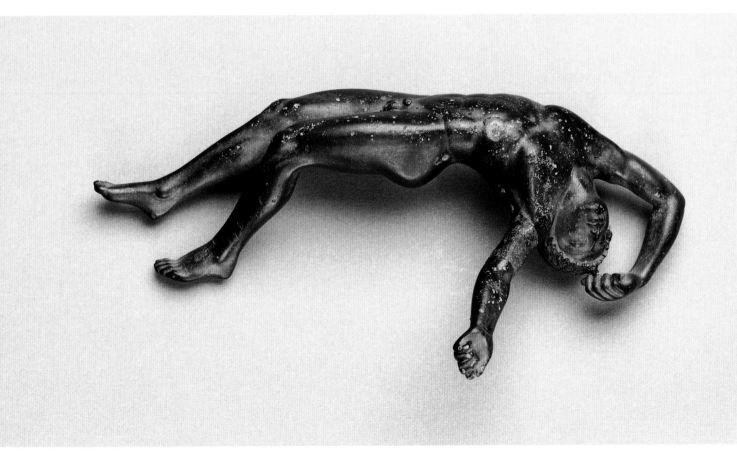

Red-Figured Calyx-Krater Showing Ge, Her Son the Titan Okeanos,
and Dionysos (side A); Themis, Balos, and Epaphos (side B)
Athens, terracotta, 470–460 B.C.

Height: 43 cm (16¾ in.)
Diameter: 54 cm (21 1/16 in.)
Signed by Syriskos (as painter)
92.AE.6

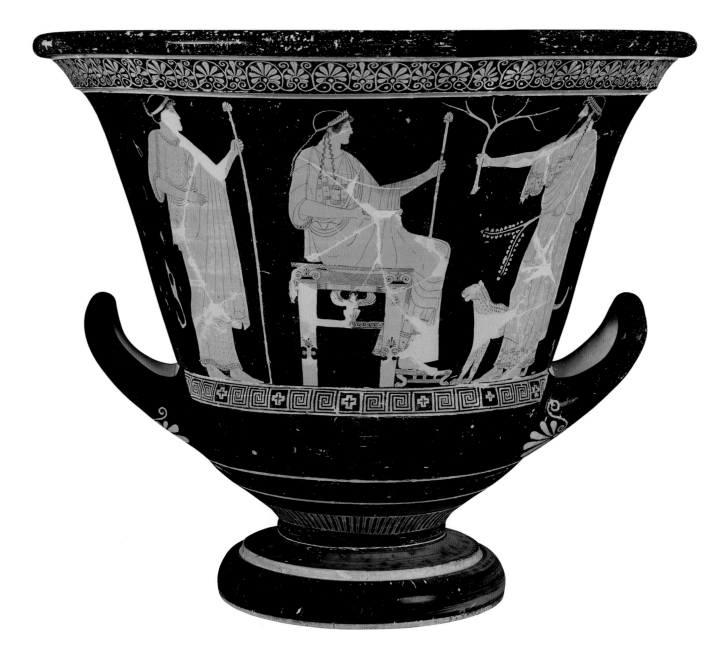

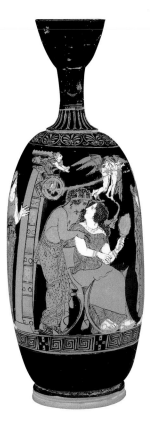

Red-Figured Lekythos Showing Helen and Paris
Accompanied by Helen's Sisters
Athens, terracotta, 420–400 B.C.

Height: 18.5 cm (7¼ in.)
Attributed to the Circle of the Meidias Painter
91.AE.10

Attic Red-Figured Footed Dinos
Showing Gods, Goddesses, and
Heroes Gathered for the Departure
of Triptolemos
Athens, terracotta, about 470 B.C.

Height: 36.8 cm (14⅜ in.)
Diameter (body): 35.7 cm (14 in.)
Attributed to the Syleus Painter
89.AE.73

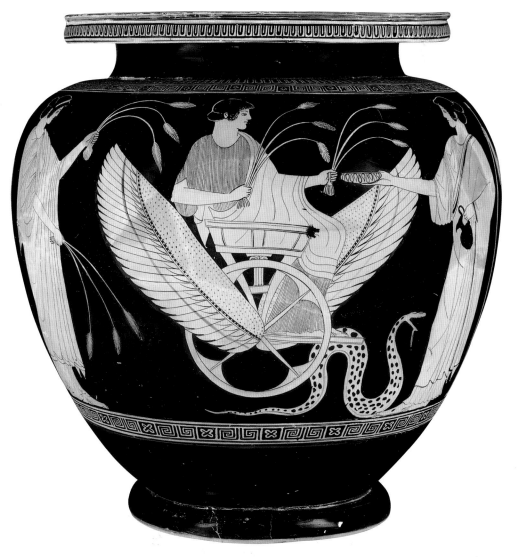

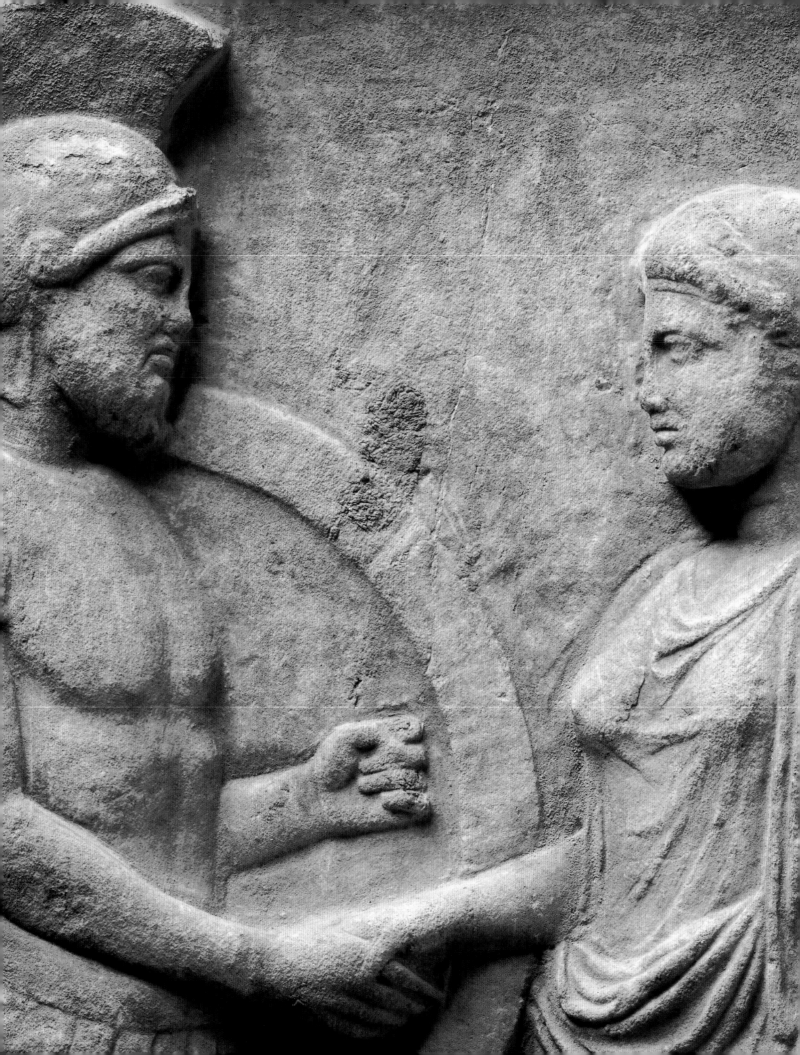

Attic Grave Stela of Philoxenos and Philomene
Athens, Pentelic marble, about 400 B.C.

Height: 102.5 cm (40 in.)
Width: 43.25 cm (16⅞ in.)
83.AA.378

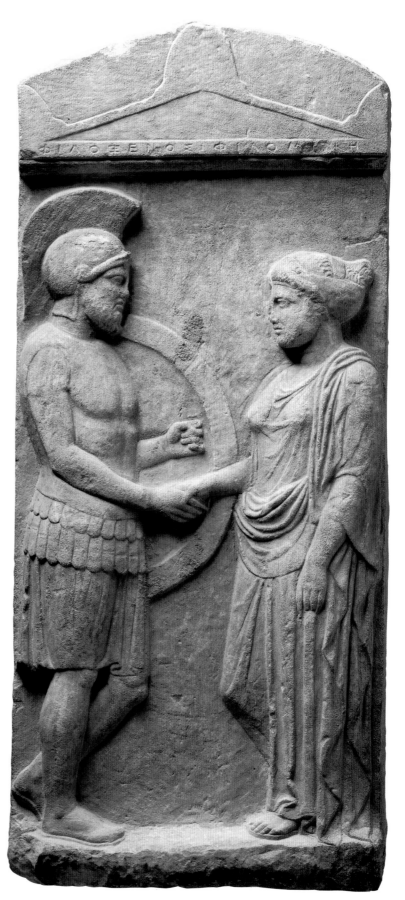

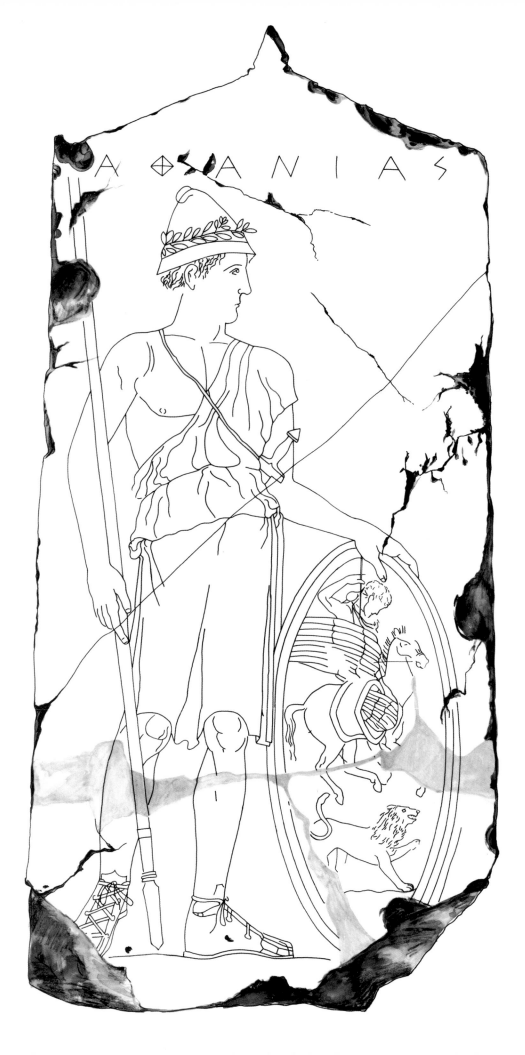

Incised Grave Stela of Athanias
Boeotia, black limestone,
late fifth – early fourth century B.C.

Height: 168 cm (65½ in.)
Width (greatest): 80 cm (31³⁄₁₆ in.)
93.AA.47

Drawing of the Incision on
the Grave Stela of Athanias

Drawing by Beverly Lazor-Bahr

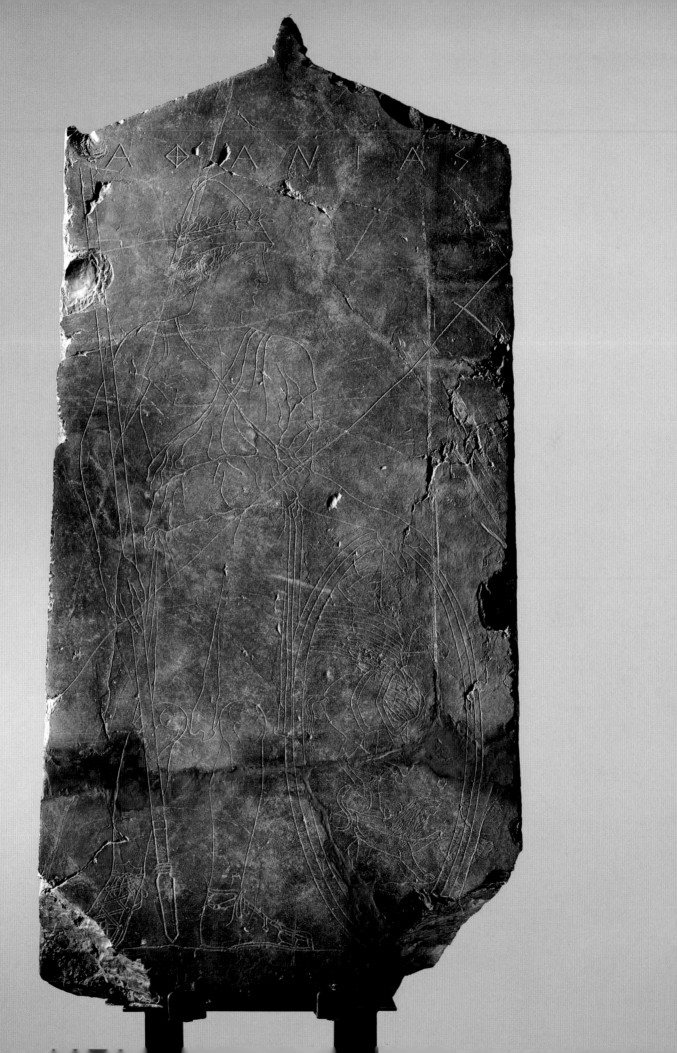

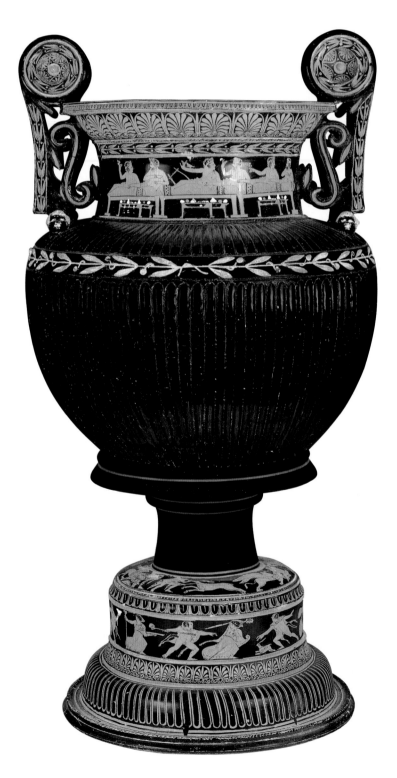

Attic Red-Figured Dinoid Volute-Krater and
Stand Showing Adonis Lying on a Couch
with Eros Offering Food and Aphrodite Sitting
at the Foot of the Bed (side A); Three Couples
Reclining on Couches at a Symposium (side B)
Athens, terracotta, 390–380 B.C.

Height: 70.6 cm (27½ in.)
Diameter (krater): 40.6 cm (15¹³⁄₁₆ in.)
Attributed to the Meleager Painter
87.AE.93

Panathenaic Prize Amphora and Lid
Showing Athena Promachos (side A);
Nike Crowning the Victor, with the Judge
on the Right and the Defeated Opponent
on the Left (side B)
Athens, terracotta, 363/362 B.C.

Height (with lid): 89.5 cm (35 in.)
Circumference (shoulder): 115 cm (44⅞ in.)
Attributed to the Painter of the Wedding Procession
(as painter); signed by Nikodemos (as potter)
93.AE.55

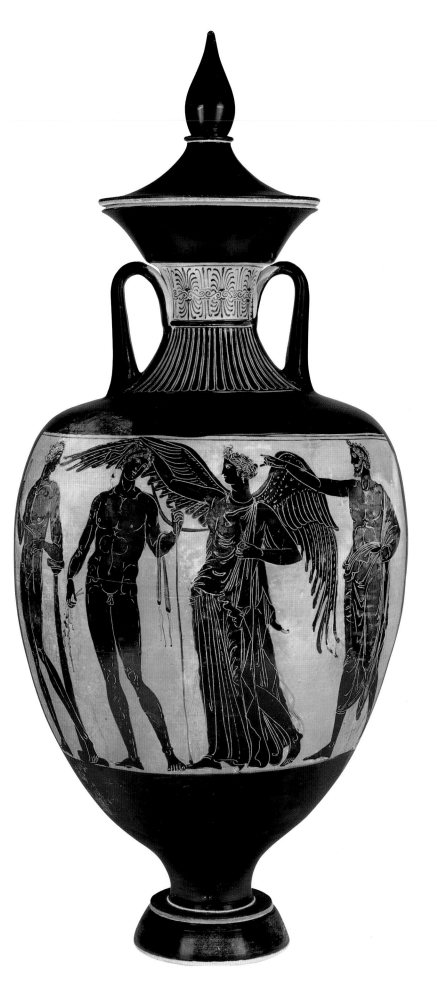

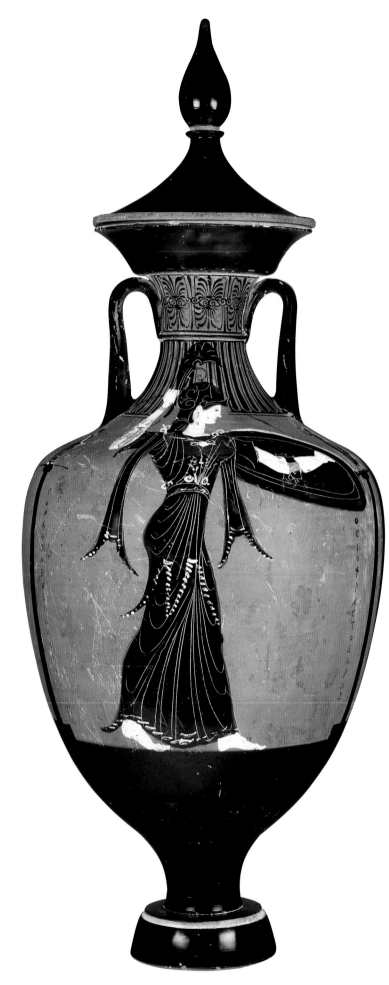

Panathenaic Prize Amphora and Lid Showing
Athena Promachos (side A); Chariot with
Charioteer and Apobates (side B)
Athens, terracotta, 340/339 B.C.

Height (with lid): 99.5 cm (38¹³⁄₁₆ in.)
Attributed to the Marsyas Painter
79.AE.147

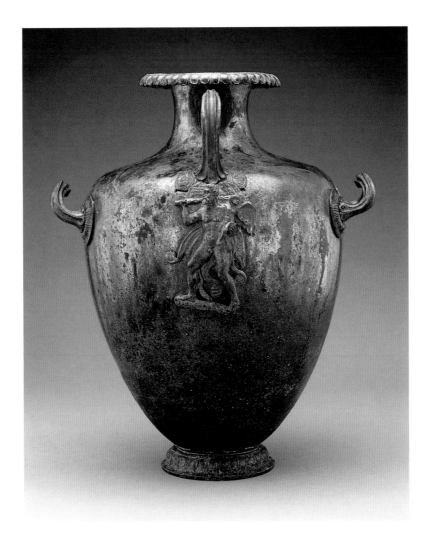

Kalpis Showing Herakles Carrying Eros
Greece, bronze, mid-fourth century B.C.

Height: 48 cm (18¾ in.)
Diameter (body): 31.5 cm (12⅜ in.)
79.AC.119

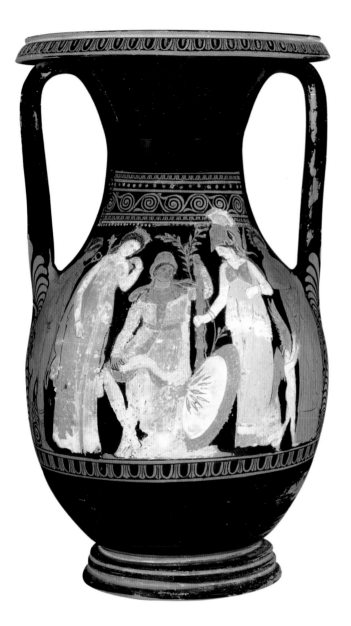

Statue of Victorious Youth
Greece, bronze,
last quarter of fourth century B.C.

Height: 151.5 cm (59⅛ in.)
Perhaps by a pupil of Lysippos
77.AB.30

Attic Red-Figured Pelike of Kerch Style with the Judgment of Paris
(side A); Two Amazons in Combat with a Greek (side B)
Athens, terracotta, 330–320 B.C.

Height: 48.3 cm (18⅞ in.)
Diameter (body): 27.2 cm (10¹³⁄₁₆ in.)
Attributed to the Circle of the Marsyas Painter
83.AE.10

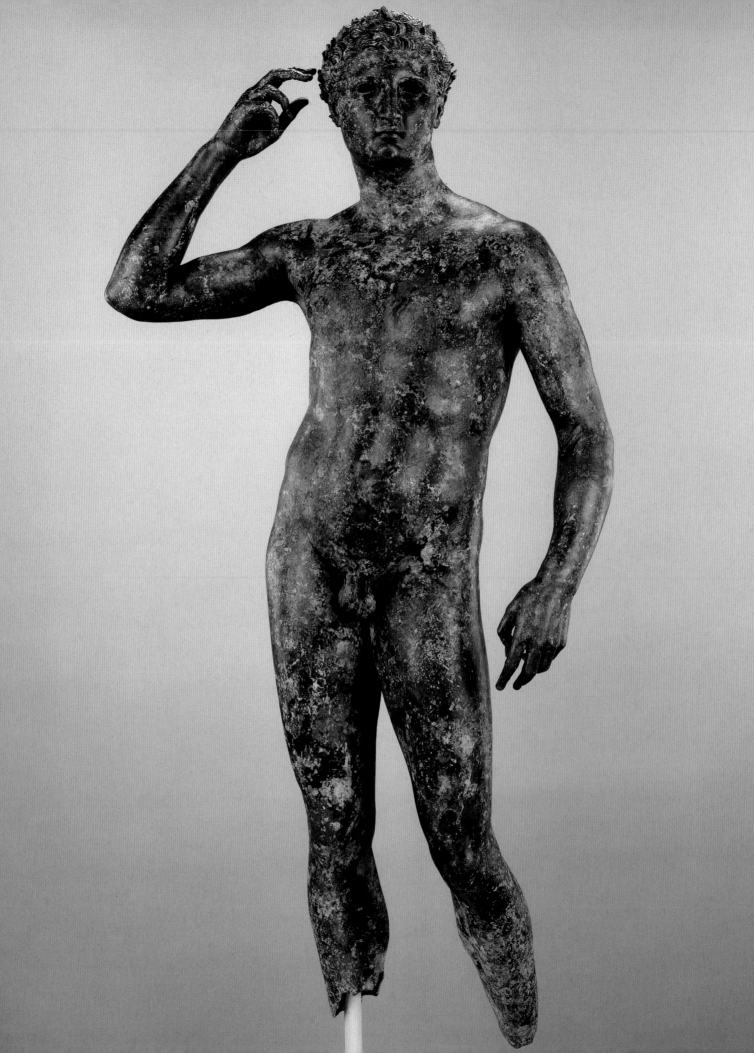

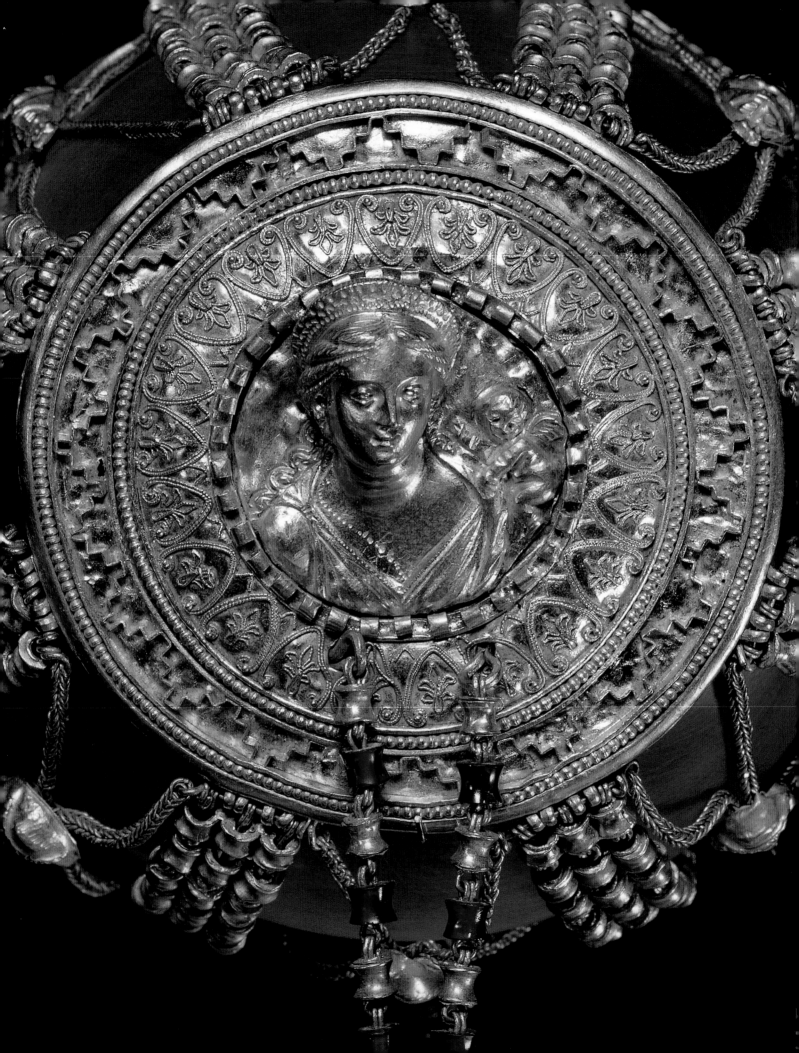

HELLENISTIC PERIOD

The Hellenistic period encompasses the years from the death of Alexander the Great in 323 B.C. to 31 B.C. when the center of power shifted from Greece to Rome after a pivotal Roman victory in the Battle of Actium. With the expansion of Alexander the Great's Macedonian Empire, the Greeks came into close contact with many new cultures that both greatly influenced the Greek artists' repertoire and gave opportunities for employment. Subjects of sculpture and painting broadened to represent a variety of people of all ages and classes in a full spectrum of emotional and physical states, in styles that ranged from idealizing to exaggerated naturalism. Also, representations of landscapes and still life were introduced. In general, art of the early Hellenistic period exhibits a great deal of dramatics, whereas later Hellenistic artists tended to revert to a more classicizing approach to the varied subject matter. Paralleled by the breaking up of the empire during the Hellenistic period, there was a growing sense of individualism, which is still visible in the greater number and particularity of individual portraits commissioned during that time.

The generals who took over various parts of the Greek world after Alexander the Great died strongly supported the visual and literary arts. The great library at Alexandria in Egypt, established by the Ptolemies, and the magnificent architectural and sculptural program of the acropolis at Pergamon in Asia Minor, with its "Altar of Zeus," by the Attalids, attest to this. Just as the Greeks with their cultural heritage influenced the new cities they entered, so, too, were foreign deities and religious beliefs, new ideas about science, and new forms of technology introduced to and, at times, incorporated into the Greek world. This eclecticism is apparent in the theatrical productions of the Hellenistic period. During the Classical period, writers of "Old Comedy," such as Aristophanes, dealt with contemporary public issues that could really be fully understood only by citizens of the Athenian *polis*. By contrast, during the Hellenistic period, "New Comedy" authors such as Menander dealt with more generalized subjects of everyday human behavior that were universally understood. The visual and literary arts of the Hellenistic period are thus characterized by diversity.

During the Hellenistic period, great wealth was accumulated by people who often left their homeland in search of financial gain in various parts of the different Hellenistic kingdoms such as Persia. This increase in personal wealth and a taste for its display are reflected in the large number of objects made from precious metals and stones. Jewelry likewise displays the result of new contacts, incorporating pearls, for instance, which were previously unknown, and emeralds and garnets from India, which became very popular. Precious items were made not only for religious vestments and offerings but very often also for individual consumption. The latter displayed the

influence of Oriental and Egyptian cultures, which placed a greater emphasis on an individual's well-being and personal enjoyment than the Greeks had previously done.

In architecture, the Greeks continued to erect buildings of all types using the same vocabulary as Archaic and Classical architects, but with greater use of the Corinthian and diminished use of the Doric order. There are some surprising alterations in Hellenistic architecture that reflect the growing interest in an individual's experience of and relationship with the structure. Some buildings incorporate the element of surprise and individual participation to produce a dramatic architectural experience. Hellenistic Greek architects took advantage of their beautiful landscape by providing exciting and unexpected vistas. They used a mathematical approach to construction, and several architects favored a very structured format in their buildings by adhering to strict grid systems.

Sculpture continued to be produced for religious purposes. However, there is a visible increase in the amount of sculpture made to adorn royal and private dwellings, reflecting the large increase in wealth that accompanied the growth of the various parts of the Greek world, especially the Persian Empire. Both religious and secular sculptures display a trend toward theatricality and hyperrealism and show the influence of the Classical artists Skopas (in the emotional representations) and Lysippos (in sculpture that is expressive with individualized forms). Hellenistic sculptors continued to pursue an interest in three-dimensionality, complex poses, and the relationship between sculpture and its manufactured setting. As with architecture, sculpture strives to engage the individual, so that a personal interaction links the viewer with the work of art. Regardless of whether an artist was working on a dramatic or a classical representation, there is an obvious debt to the advances made by Classical artists such as Polykleitos and Phidias.

Head of Alexander the Great
Pentelic (?) marble, about 310 B.C.

Height: 28 cm (10^{15}/$_{16}$ in.)
73.AA.27

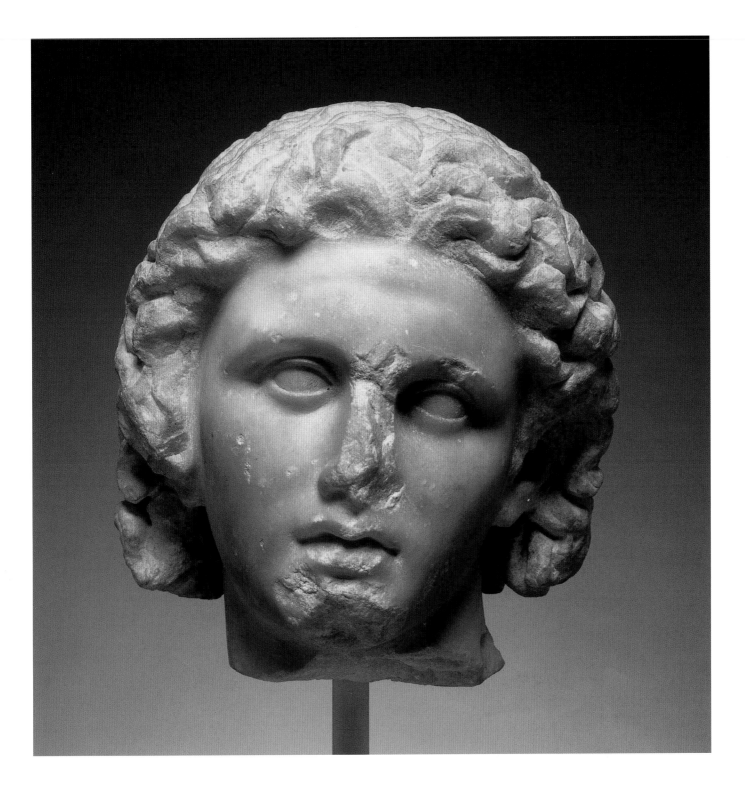

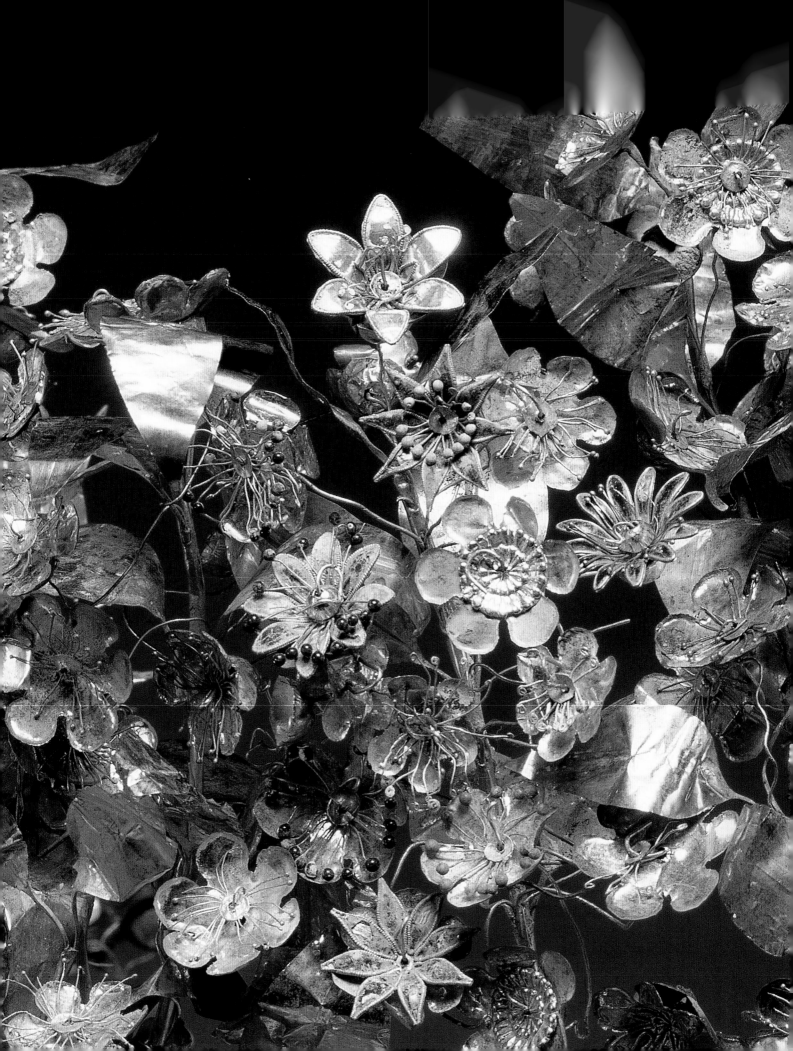

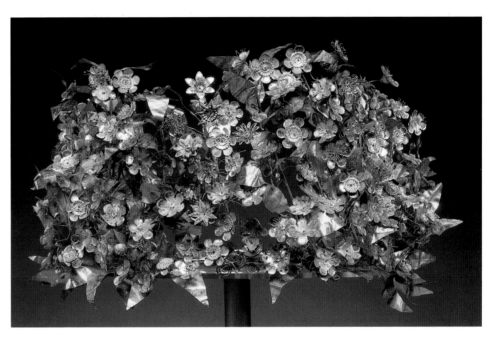

Funerary Wreath
Greece, gold with blue and green glass-paste inlays,
late fourth century B.C.

Diameter: 30 cm (11^{11}⁄$_{16}$ in.)
93.AM.30

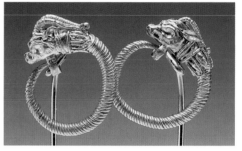

Part of a Collection of Ptolemaic Jewelry
Alexandria (?), gold with various inlaid and
attached stones, 220–100 B.C.

Hair Net with Aphrodite and Eros on the Medallion
Height: 21.5 cm (8½ in.)
Width: 8 cm (3⅛ in.)
92.AM.8.1

Hoop Earrings with Antelope-Head Finials
Greatest extent: 21 mm (⅞ in.)
92.AM.8.4

Pair of Upper-Arm Bracelets in the Form
of a Coiled Snake
Diameter: 7.8 cm (3¹⁄₁₆ in.)
92.AM.8.6

Diadem with a Herakles Knot in the Center
Diameter: 17.5 cm (6⅞ in.)
92.AM.8.2

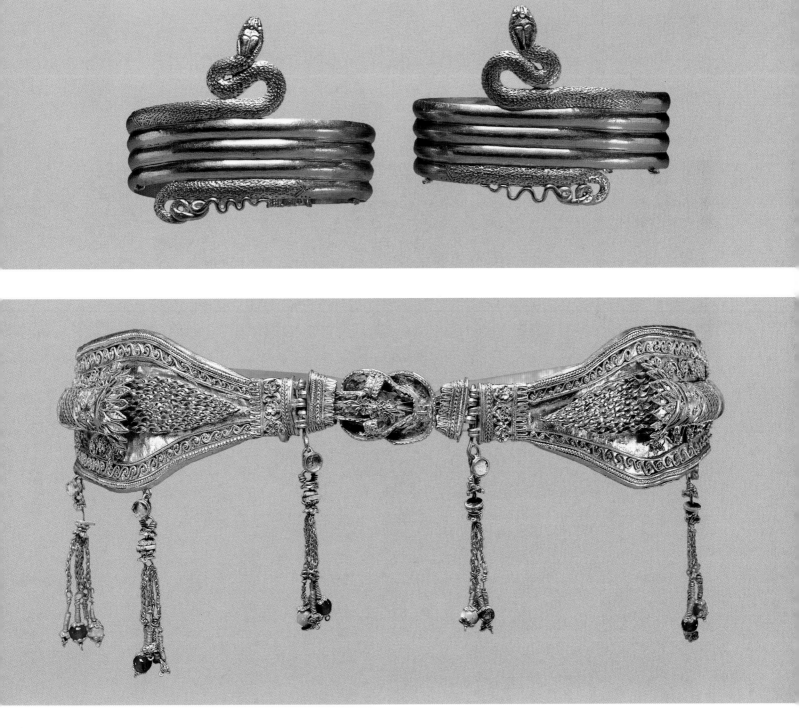

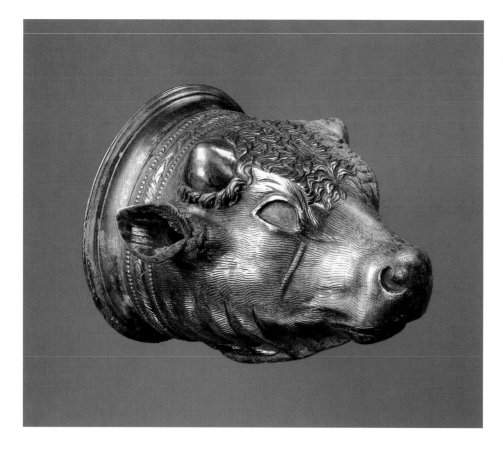

Bull's-Head Cup with Separable Liner
East Greece, silver with leaf gilding,
second century B.C.

Height (head): 12.1 cm (4¹¹⁄₁₆ in.)
Diameter (bowl): 9.5 cm (3¾ in.)
87.AM.58

Alabastron
East Greek Empire (perhaps
Seleucid or Ptolemaic), faience,
second century B.C.

Height: 23 cm (9 in.)
88.AI.135

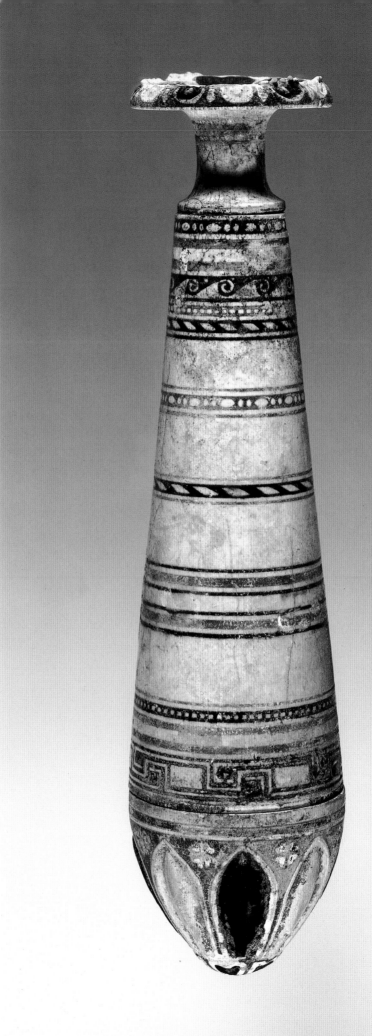

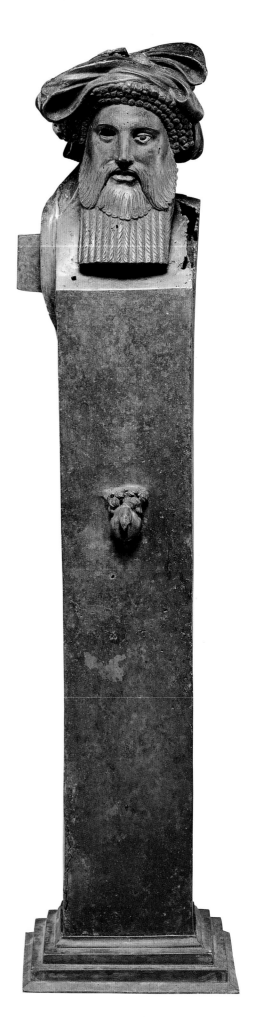

Herm
Bronze with ivory inlay, 100–50 B.C.

Height: 103.5 cm (40⅜ in.)
Width (base): 23.5 cm (9³⁄₁₆ in.)
Workshop of Boethos
79.AB.138

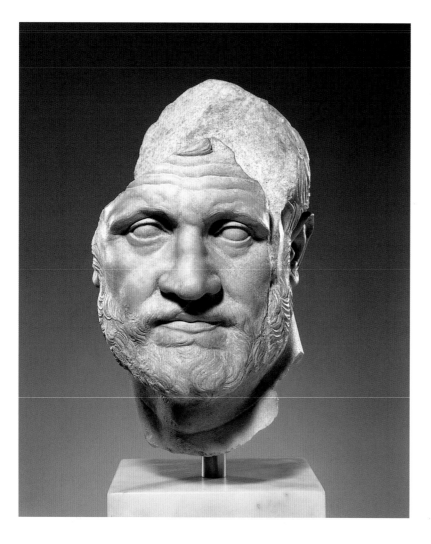

Portrait Head of a Ruler
Greece, marble, mid-second century B.C.

Height: 40.7 cm (15⅞ in.)
Width: 25 cm (9¾ in.)
91.AA.14

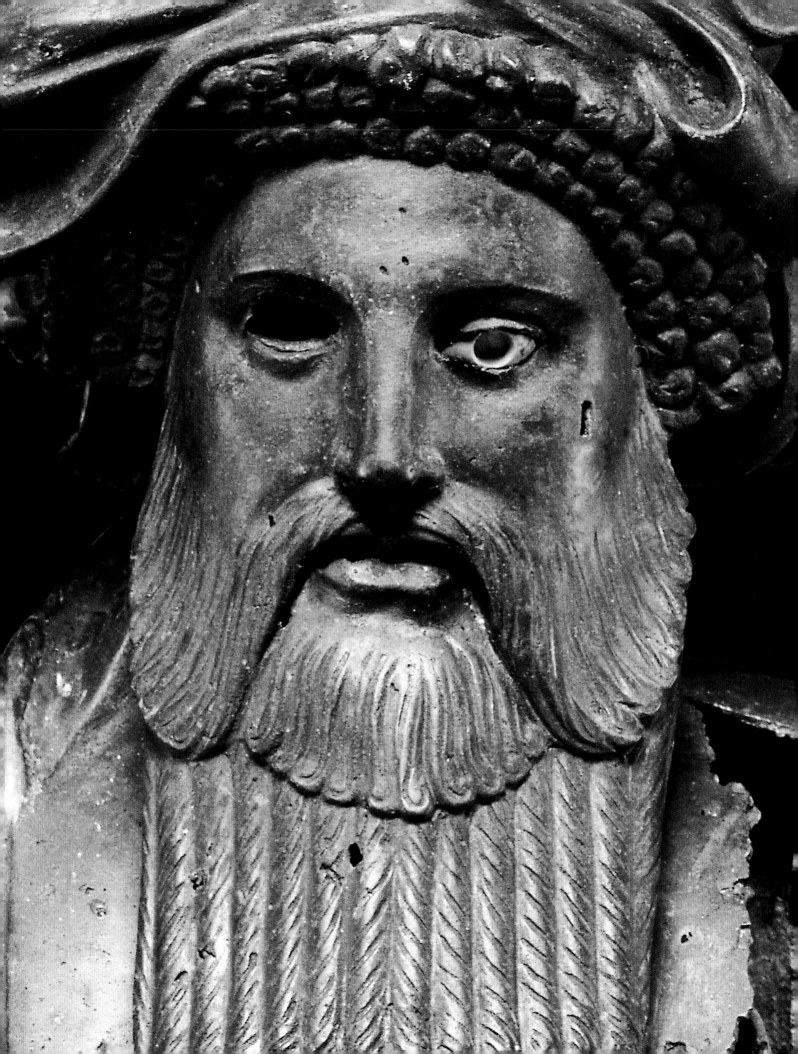

Stag Rhyton
Eastern Seleucid Empire, gilt silver with inlaid glass eyes,
first century A.D.

Height: 26.5 cm (10⅜ in.)
Diameter (rim): 12.7 cm (4¹⁵/₁₆ in.)
86.AM.753

<div align="right">

Bowl
Eastern Seleucid Empire,
gilt silver and garnets,
first century B.C.

Diameter: 20 cm (7¹³/₁₆ in.)
86.AM.752.3

</div>

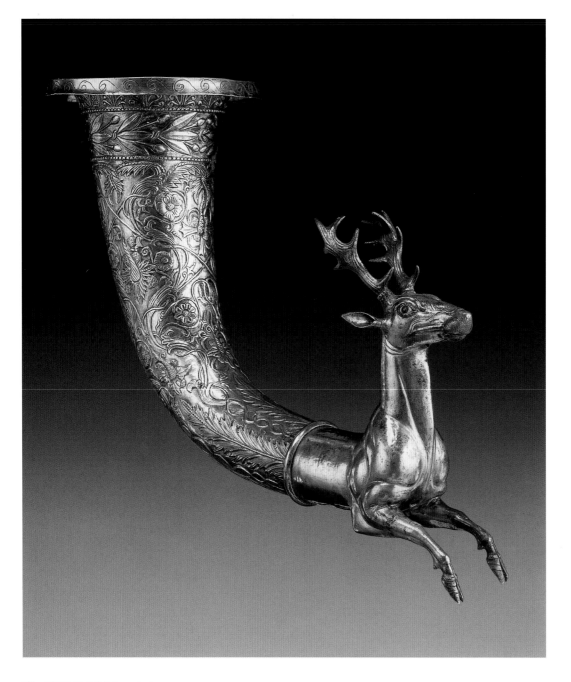

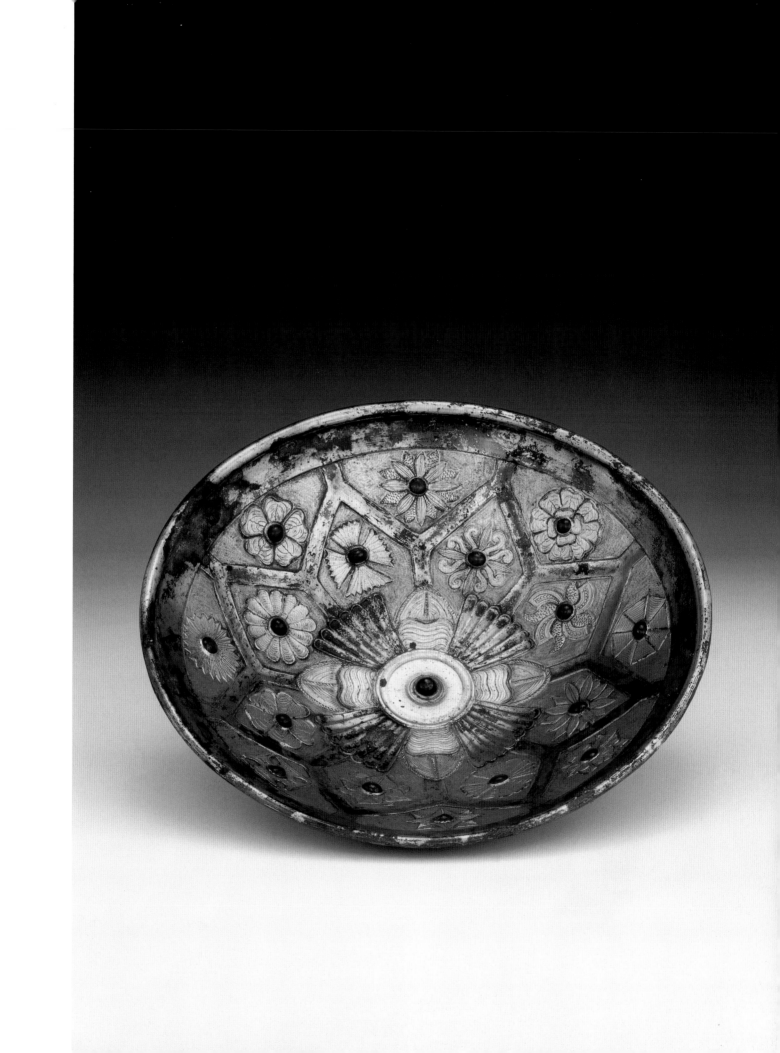

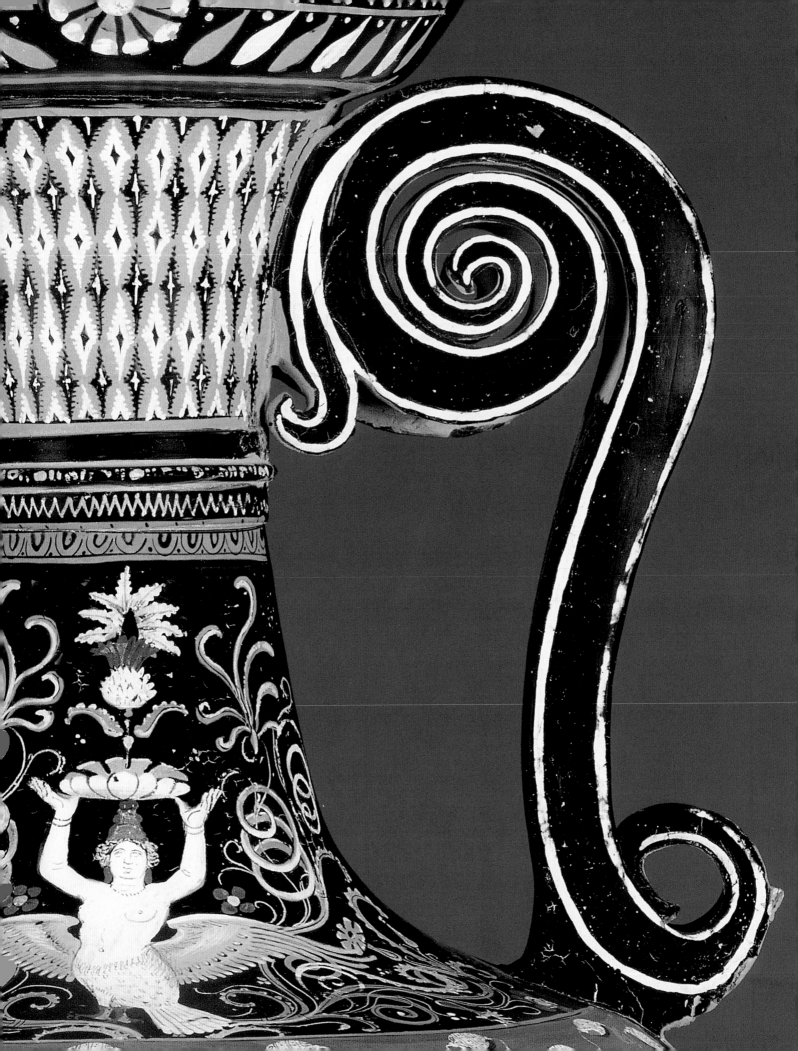

ETRURIA AND SOUTH ITALY IN THE PREROMAN PERIOD

Before they were ultimately unified through Roman conquests that ended in the first century B.C., the various regions of Italy, including Latium, Etruria, Apulia, Campania, and Sicily, were inhabited by peoples of different ethnic groups. The Etruscans were one of the most powerful peoples in Italy before the rise of Rome. Their original territory extended inland from the coast of the Tyrrhenian Sea, between the Tiber and the Arno. The Etruscans' wealth grew rapidly at the end of the eighth century B.C. when they started selling their rich mineral deposits on a large scale to Greece and other countries. At the same time, their flourishing arts also showed great influence from Greece, due in no small part to the large number of Greek artists who settled in Etruria to work for the newly wealthy patrons. The Etruscans continued to expand their territory until the fifth century B.C., when the Greeks and Carthaginians gained control of the sea routes, which led to the political and economic decline of Etruria. The Etruscans, however, continued to absorb Classical and Hellenistic influences from Greece, just as they had during the Archaic period, at the height of their power.

In Etruscan architecture, the basic plan for the temple, which was described by Vitruvius as "Tuscan," was a wide building with long eaves, three *cellae* (or sometimes a single one with open wings on either side), and four columns in front. The whole structure stood on a high podium and had a single entrance. Temples were decorated on the inside with painted scenes and on the outside with antefixes, acroteria, and pedimental sculpture. Etruscan architecture shows some similarities with Greek architecture, yet it also maintains a very distinct native style.

Much of what survives of Etruscan art is related to the funeral and exists today because it was made for, and included in, the burial. Urns and sarcophagi, sometimes adorned with a likeness of the individual, were made to house the ashes of the deceased. Tomb chambers were colorfully decorated with frescoes or stone reliefs depicting scenes of everyday life, including banquets, hunts, and the funeral itself. Examples of the highly advanced, intricate indigenous art of Etruscan jewelry production, such as earrings, were sometimes included in the tombs.

In general, Etruscan art shows great diversity in subject, medium, and technique, giving evidence of an advanced society, whose interests focused more on aspects of everyday life than on the universal ideal that attracted the Greeks. Etruscan art was greatly influenced by Greek art and in turn influenced the art of other regions in the Italic peninsula.

The people of southern Italy and Sicily came into touch with Greek writing, urban society, and artistic styles and motifs from the eighth century B.C. onward, when Greek colonies were established in the region known as Magna Graecia. Contact between

Greece and southern Italy had existed already during the Bronze Age (3000–1100 B.C.), especially at the height of the Mycenaean period, when a great deal of trading occurred. In the early Archaic period (650–580 B.C.), not only were objects imported from Greece, but Greek artists were among the groups that colonized Magna Graecia. Local artists extensively imitated the imported wares, especially vases from Corinth and from islands in the Aegean. The artists in southern Italy initially very strongly represented Greek gods, heroes, and myths for their patrons, and they produced types of art similar to those in Greece, including black- and red-figured vases, monumental cult statues, votive offerings, architecture and architectural sculpture, and jewelry. The colonies of southern Italy did not have the same resources as those that were available to the cities of Greece, such as good-quality marble, but were constrained to work with local materials. Sculptors worked in terracotta or substituted less expensive and more readily available materials, such as limestone, for the painted parts of stone statues, reserving marble for features, such as the face and hands, where the material would be visible.

Just as the sixth century B.C. saw growth in population and wealth on the Greek mainland, so, too, did this occur in the Greek colonies in southern Italy through increased trade and closer contact with Greece. Cities such as Sybaris and Paestum were known for their grandeur and refinement. By the end of the fifth century B.C., the Greek colonized world entered a new phase of independence. As a result of the wars between Carthage and Syracuse for control of Sicily, the fall of the Greek colonies on the Tyrrhenian coast, and the failure of the Athenian attempt at western expansion, the Greek colonies in southern Italy turned away from the Greek world and focused more on their own peninsula. Tarentum and Campania, especially, became major cultural and artistic centers in Italy that influenced many other cities, including Etruria and Rome in the north.

Caeretan Hydria Showing Herakles and Iolaos Slaying the Lernan Hydra
Etruria, terracotta, about 525 B.C.

Height: 44.6 cm (17⅜ in.)
Diameter (body): 33.4 cm (13 in.)
Attributed to the Eagle Painter
83.AE.346

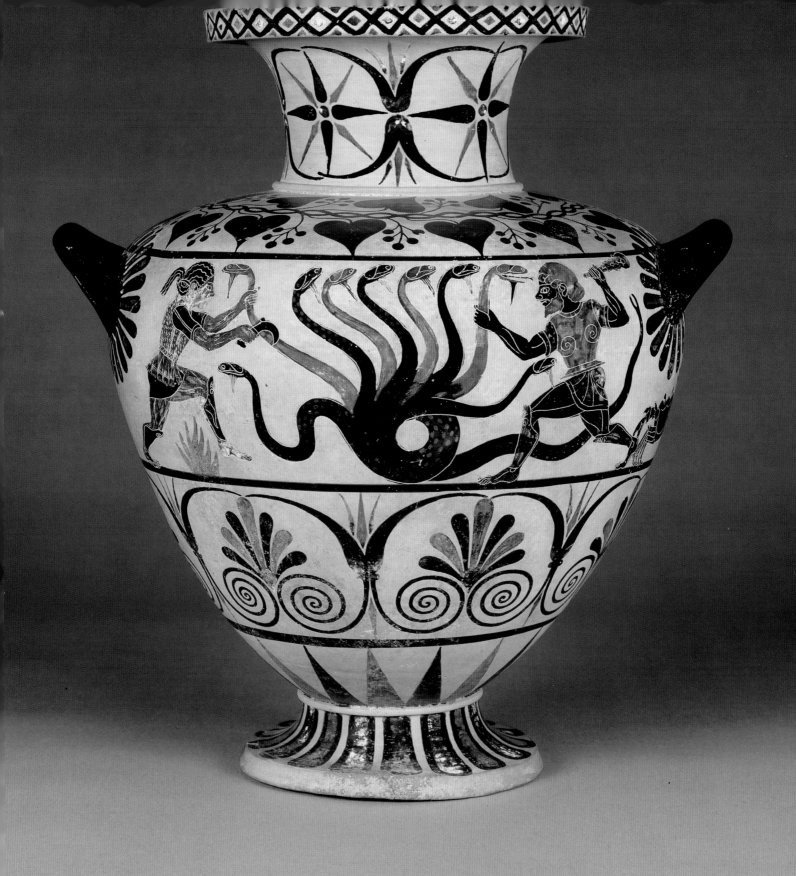

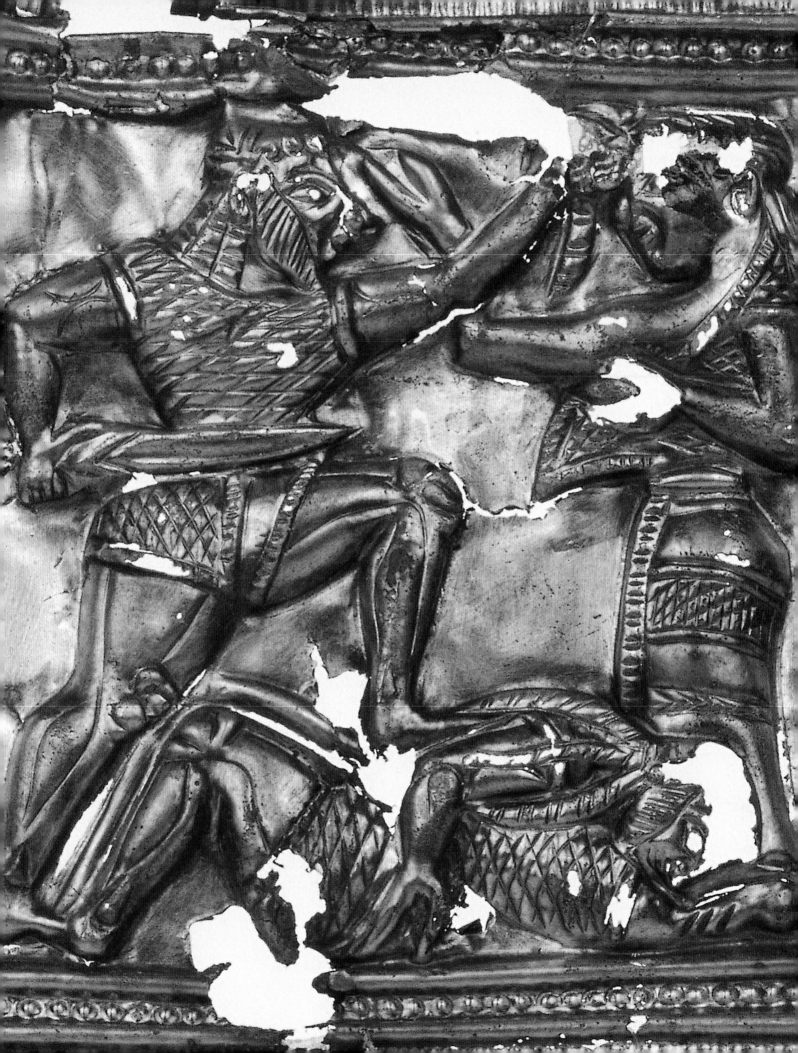

Pair of Earrings with
Little Heads and Rosettes
Etruria, gold, late sixth century B.C.

Diameter: 4.8 cm (1⅞ in.)
83.AM.2.1

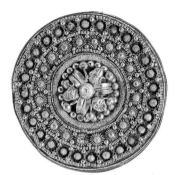

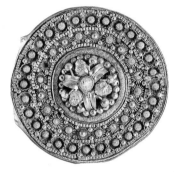

Relief Fragment with Mythological Scenes
South Italy, gilt silver, about 500 B.C.

Height: 8.4 cm (3⁵⁄₁₆ in.)
Length: 28.7 cm (11⁵⁄₁₆ in.)
83.AM.343

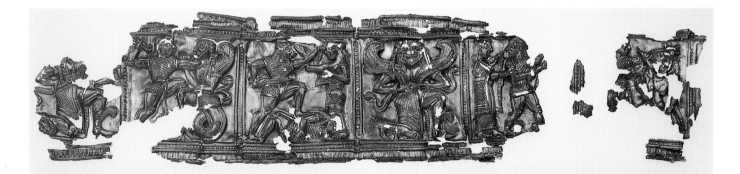

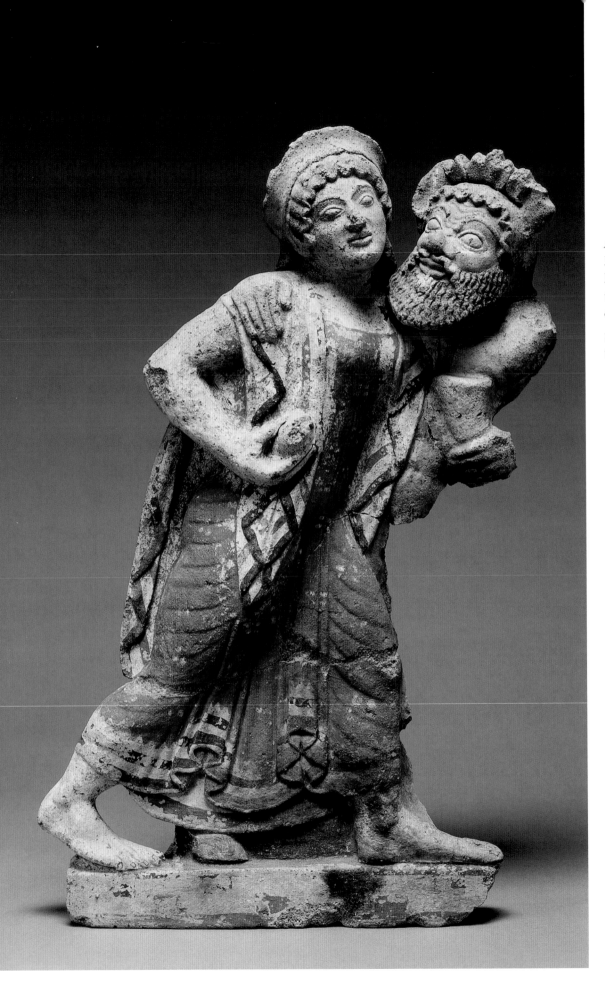

Antefix in the Form of a
Maenad and Silenos Dancing
Etruria (South Etruscan),
terracotta,
early fifth century B.C.

Height: 54.6 cm (21⁷⁄₁₆ in.)
96.AD.33

Thymiaterion Supported by a
Statuette of Nike
South Italy (Tarentum or Sicily),
terracotta, 500–480 B.C.

Height: 44.6 cm (17⅜ in.)
86.AD.681

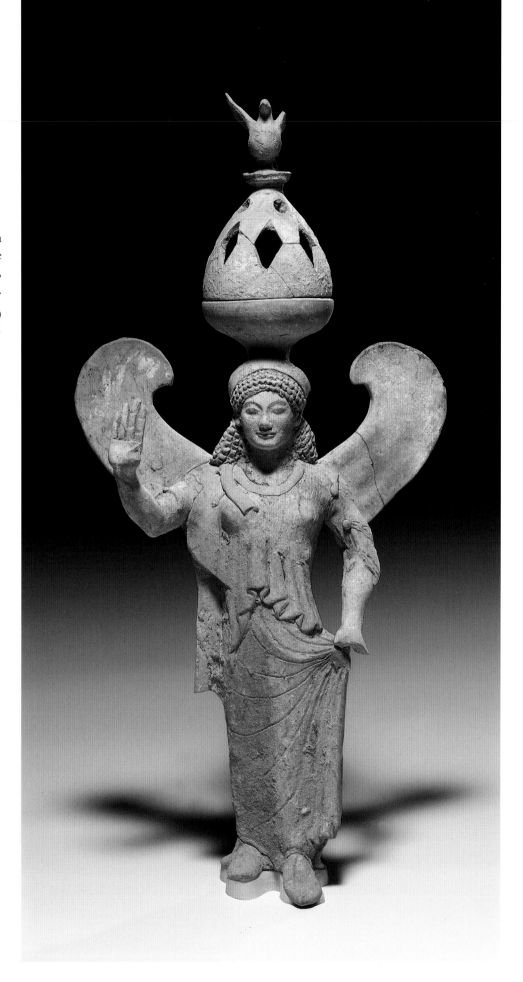

Askos in the Shape of a Siren
South Italy, bronze, first half of fifth century B.C.

Height: 15.3 cm (6 in.)
Length: 18.7 cm (7⁵⁄₁₆ in.)
92.AC.5

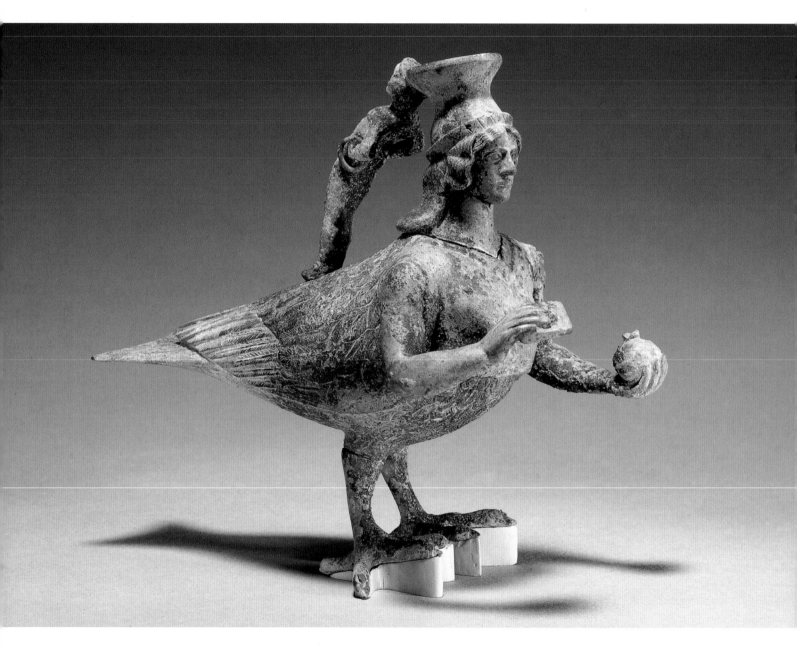

Statuette of Zeus
Etruria (Piombino), bronze, about 480 B.C.

Height: 17.2 cm (6¹¹⁄₁₆ in.)
55.AB.12

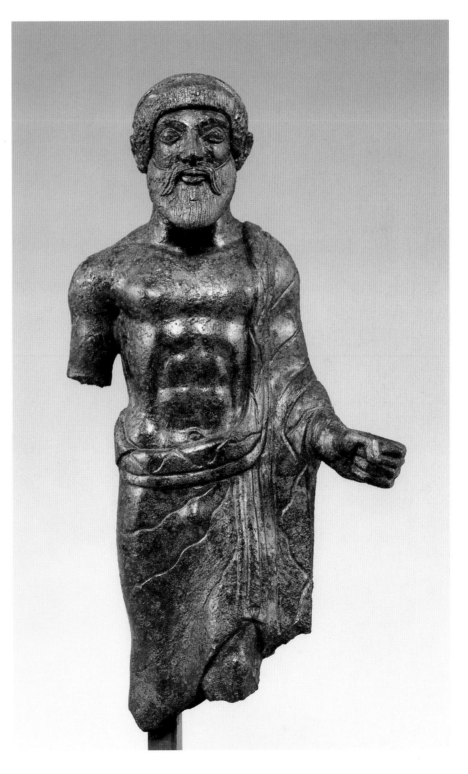

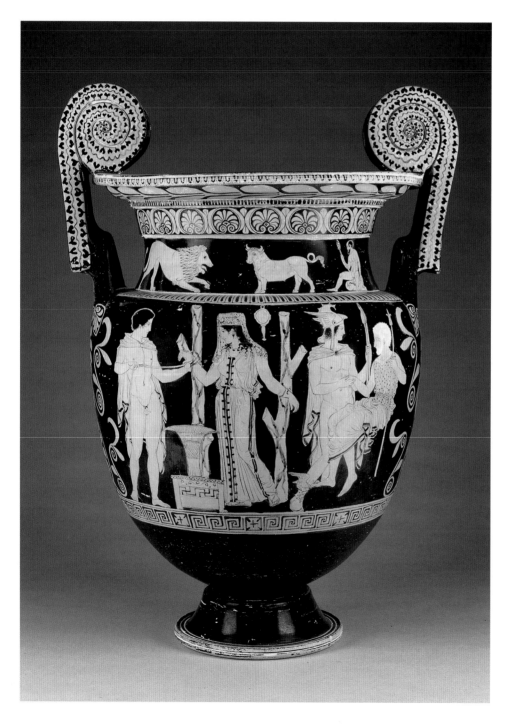

Red-Figured Volute-Krater with
the Binding of Andromeda and the
Pact between Perseus and Cepheus
(side A); Two Youths Flanked by
Two Women (side B)
South Italy (Apulia), terracotta,
430–420 B.C.

Height: 63 cm (24⁹⁄₁₆ in.)
Diameter (mouth): 37.5 cm (14⁵⁄₈ in.)
Attributed to the Sisyphus Painter
or the Circle of the Sisyphus Painter
85.AE.102

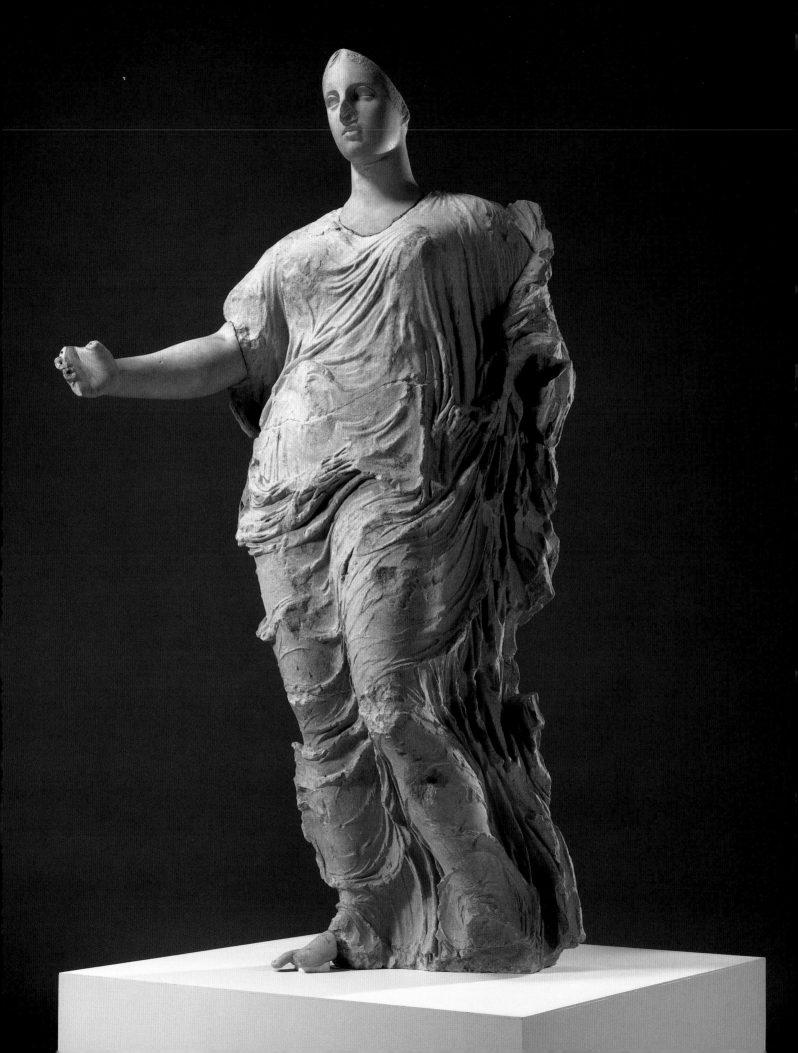

Pair of Altars with Relief Decoration of Three Women on One Altar
Looking to Adonis and His Companions on the Other
South Italy (Tarentum), terracotta, first quarter of fourth century B.C.

Height: 41.8 cm (16⁵⁄₁₆ in.)
Width (top): 31.5 cm (12⁵⁄₁₆ in.)
86.AD.598

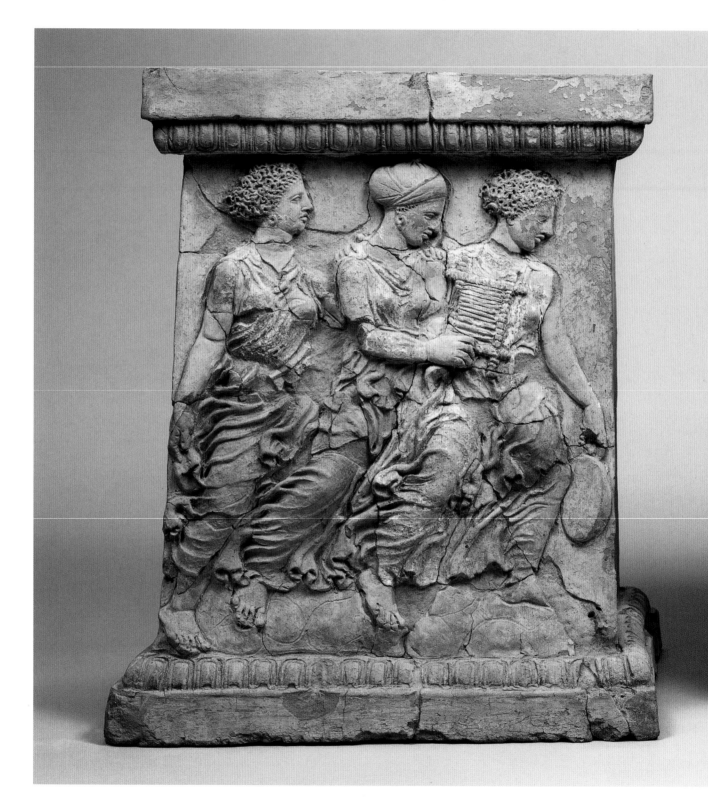

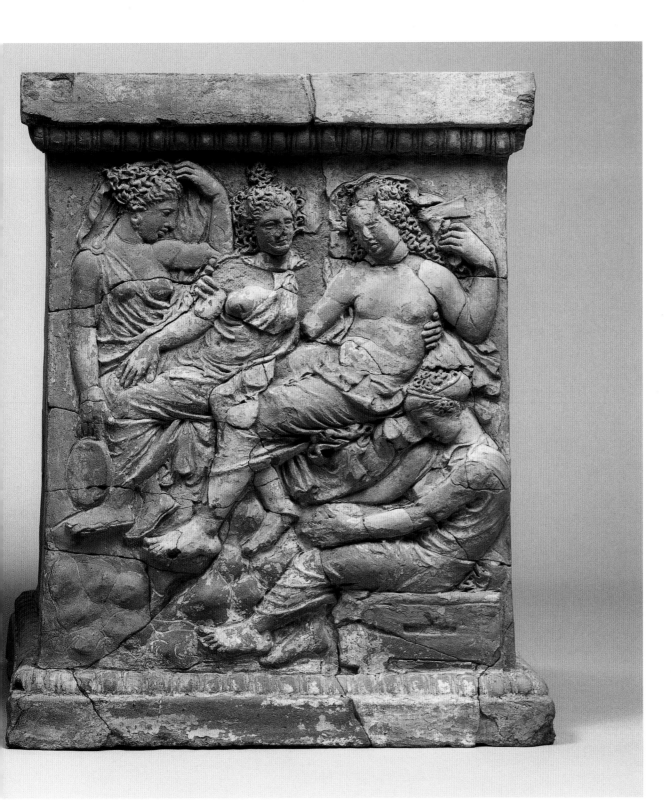

Neck-Amphora with Kapaneus Climbing a Ladder up the City
Wall of Thebes (side A); Three Satyrs and Two Maenads in a
Landscape (side B)
South Italy (Campania), terracotta, about 375 B.C.

Height: 63.4 cm (24¾ in.)
Attributed to the Caivano Painter
92.AE.86

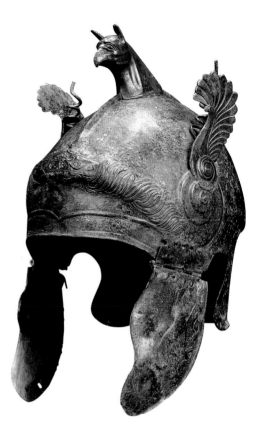

Helmet of Chalcidian Shape with a Griffin Protome
South Italy, bronze, 350–300 B.C.

Height (without cheek flaps): 28 cm (11 in.)
Width: 16.3 cm (6⅜ in.)
93.AC.27

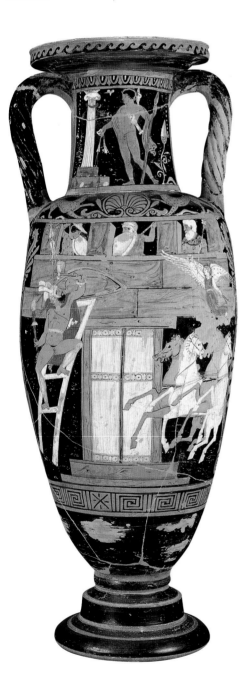

Red-Figured Calyx-Krater with the Abduction of Europa (side A);
Dionysos with Satyrs and Maenads (side B)
South Italy (Paestum), terracotta, about 340 B.C.

Height: 71.2 cm (27¾ in.)
Diameter: 59.6 cm (23¼ in.)
Signed by Asteas (as painter)
81.AE.78

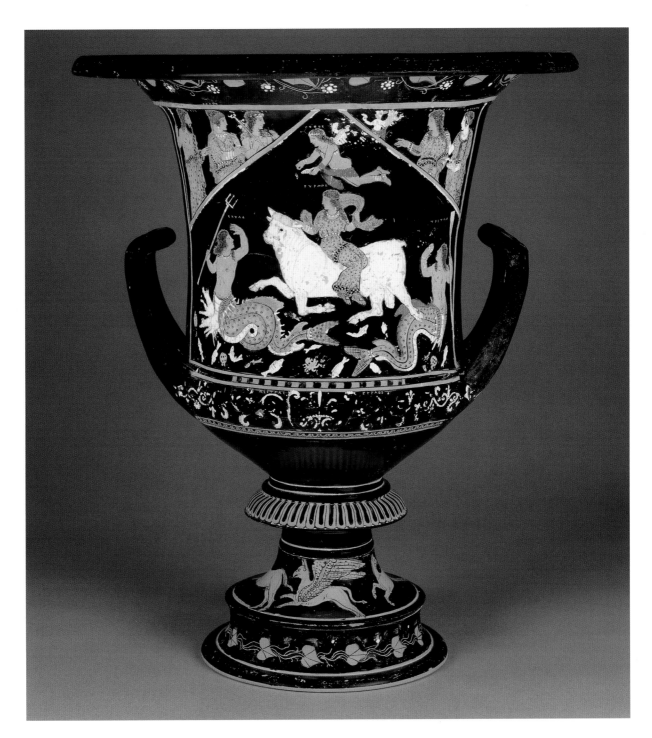

Seated Poet (perhaps Orpheus) and Sirens
South Italy (Tarentum), terracotta, about 310 B.C.

Height (Poet): 104 cm (40⁹⁄₁₆ in.)
Height (Sirens): 140 cm (54⅝ in.)
76.AD.11

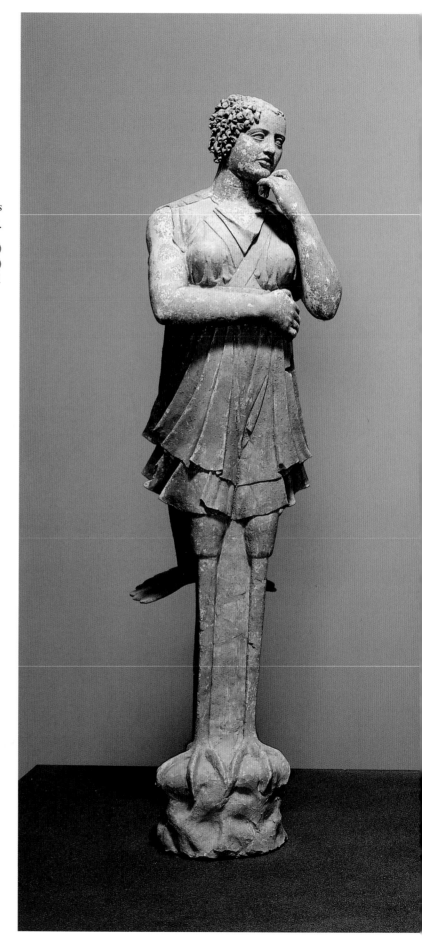

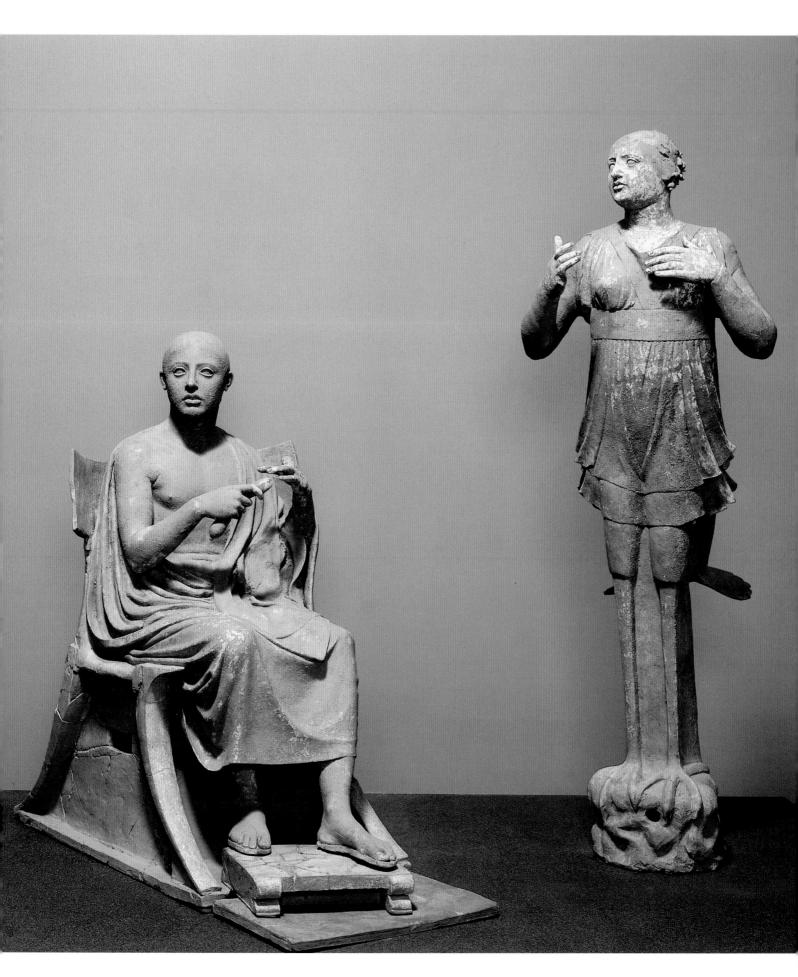

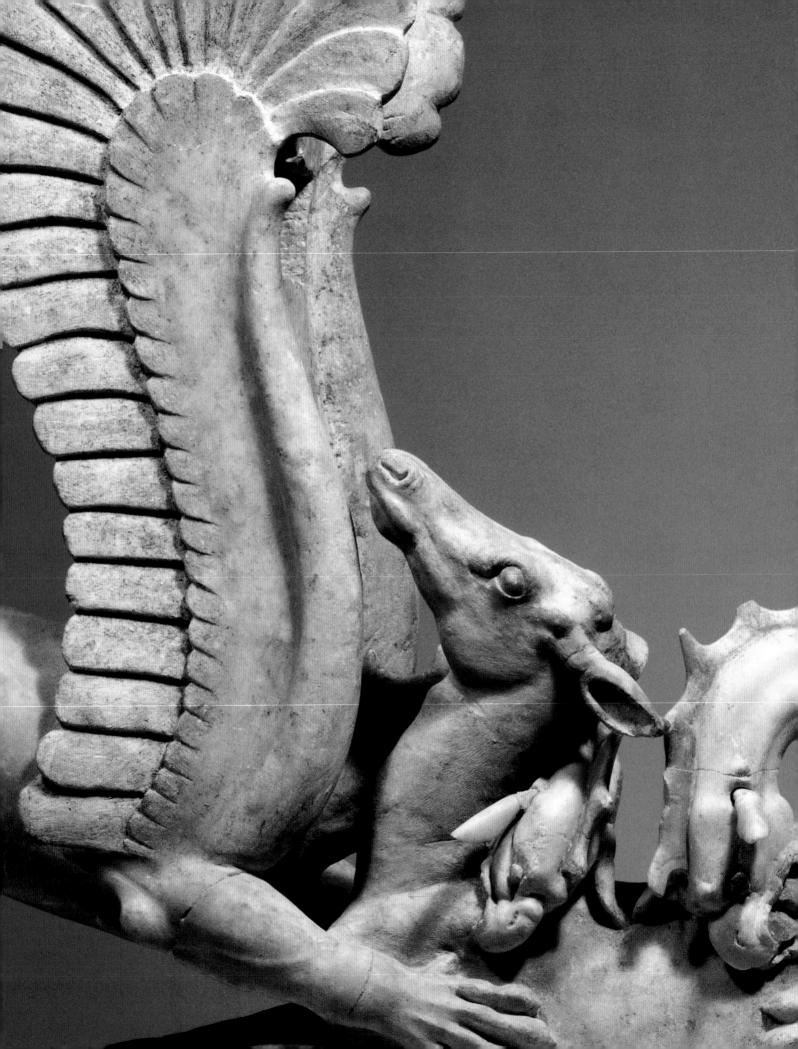

Sculptural Group (table support) of Two Griffins
Attacking a Fallen Doe
South Italy, Asia Minor marble with polychromy,
late fourth century B.C.

Height: 95 cm (37$\frac{1}{16}$ in.)
Length (base): 148 cm (57$\frac{3}{4}$ in.)
85.AA.106

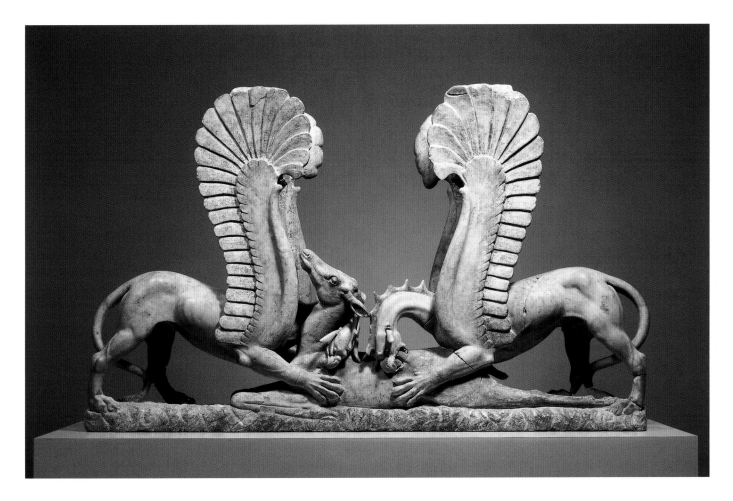

Lekanis with Thetis and Nereids Carrying Arms to Achilles
South Italy, polychromy on marble, late fourth century B.C.

Height: 30.8 cm (12 in.)
Width: 60 cm (23⅜ in.)
85.AA.107

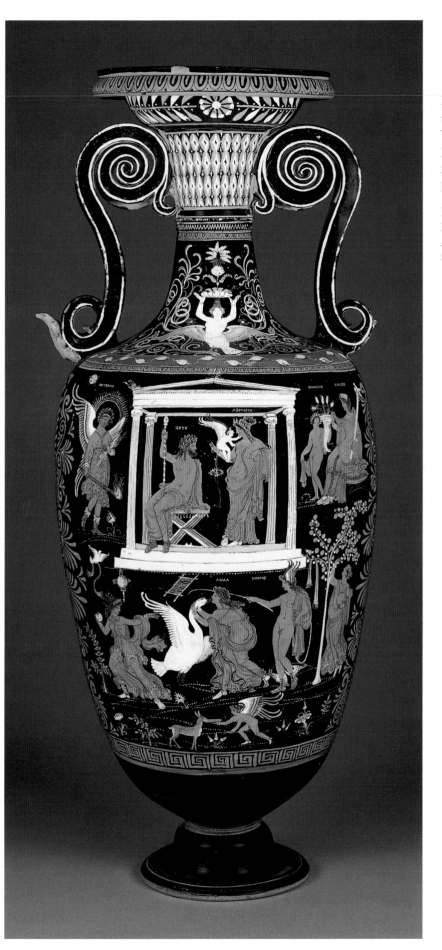

Red-Figured Loutrophoros Showing Leda and
the Swan below Zeus and Aphrodite (side A);
Woman Seated in a Funerary Monument with
Mourners around (side B)
South Italy (Apulia), terracotta,
late fourth century B.C.

Height: 90.1 cm (35⅛ in.)
Diameter (mouth): 26 cm (10⅛ in.)
Attributed to the Painter of Louvre MNB 1148
86.AE.680

Engraved Gem Inset into
a Hollow Ring, Showing
a Youth Feeding a Dog
Italy, gold and carnelian,
third–second century B.C.

Gem: 18.1 x 13.2 mm (¹¹⁄₁₆ x ½ in.)
85.AN.165

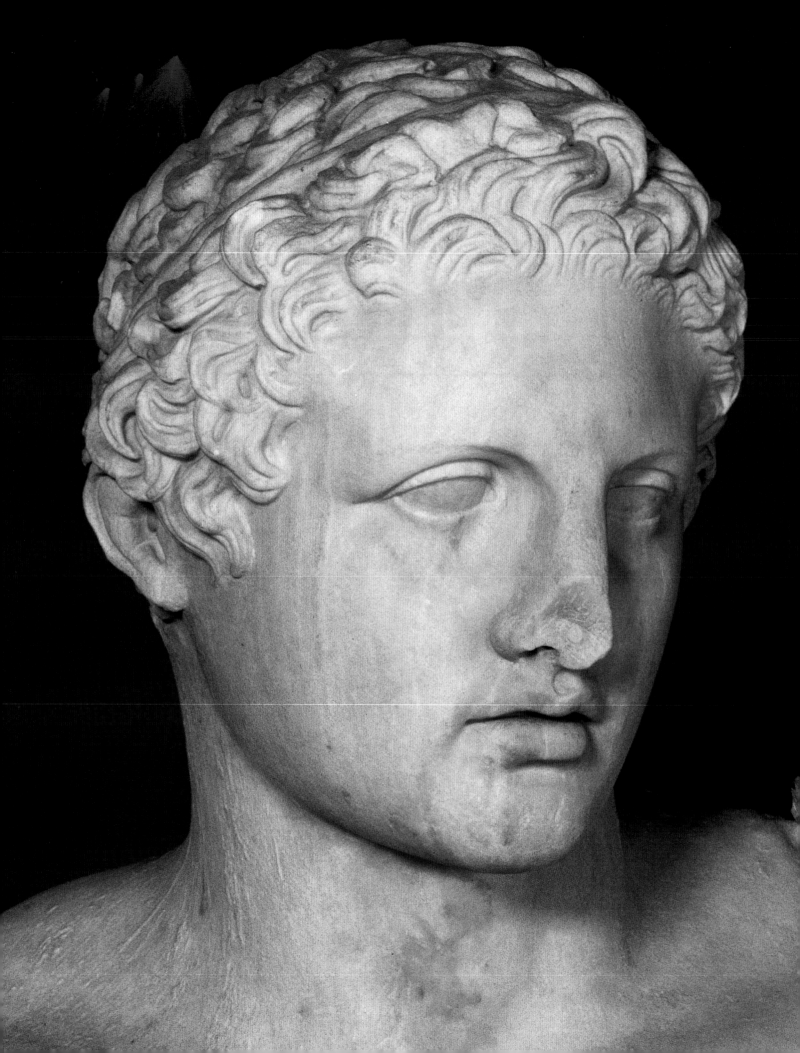

REPUBLICAN AND IMPERIAL ROMAN PERIODS

The founding of Rome by Romulus, traditionally dated to 753 B.C., perhaps reflects the unification of several Iron Age communities. At that time, Rome was one of the many cities in the region known as Latium, whose peoples were part of the Italic tribes. Several other Italic regions that flourished during the middle of the eighth century B.C. would also have a profound influence on the development of Rome, in particular, Etruria and regions of South Italy. Little is known about the early history of Rome, for there are few literary records and few physical remains due to later phases of the city being built over the most ancient parts. Archaeological evidence does suggest that the first settlements were located on the Palatine hill, with others later established on the six surrounding hills of Rome. The valleys between the hills were used for burials. During the later part of the seventh century B.C., Rome was ruled by Etruscan kings. Under them, the valley between the Palatine and the Capitoline hills was drained and became the civic center, known as the Forum, with temples and public buildings. Although the last of the seven Etruscan kings, Tarquinius Superbus, was driven from the city in the late sixth century B.C., Etruscan culture continued to exert a great influence on Rome.

Under a republican form of government, Rome increased in size and strength, becoming the major power of the Italic peninsula by the early third century B.C., and by the end of the second century B.C., the most powerful state in all the Mediterranean. To celebrate independence from the Etruscans, the Romans dedicated a temple on the Capitoline hill to Jupiter, Juno, and Minerva, parts of whose substructure still survive. Although the Capitoline temple was adorned with sculpture and cult statues, they were made by Etruscan artists, such as Vulca, who, according to Pliny the Elder, made the cult statue of Jupiter. Varro writes that the Romans did not produce any images of gods for the first 170 years of the city's history. The making of anthropomorphic images of deities was a Greek practice, which was later incorporated into the Etruscan culture and ultimately adapted into that of Rome. The Romans came greatly to value all things Greek—art, religion, literature, and philosophy. This is especially evident in the number of works of art that were plundered from Greek cities and brought to Rome.

During the early Roman Republican period, most of the monumental sculpture, including the cult statue of Jupiter by Vulca, was made of terracotta, for there was little stone suitable for carving in central Italy. Early sculptors of Latium were also fond of bronze, as seen in the statue of the wolf suckling Romulus and Remus in the Capitoline Museum. Bronze portraits of contemporary Romans increased in number during the Republican period. Like the Etruscans, the Romans depicted people clothed, in contrast to the Greek preference for nudity. The Romans, like the Greeks, placed these statues of public and private figures in homes and public spaces.

The origin of Roman portraiture is often ascribed to the practice of carrying portraits, called *imagines,* of the deceased and ancestors in funerary processions. This practice is described by ancient authors, such as the Roman Pliny the Elder and the second-century-B.C. Greek historian Polybius. However, the Romans were not the first to produce portraits, nor were they unique in their realistic representations of individuals. Portraiture had long been an important aspect of Egyptian art and was introduced into Greece early in the fourth century B.C. During the Hellenistic period, it was common for people to have their true likenesses preserved in sculpture. The Etruscans also produced many realistic portrait heads that often decorated funerary urns. Many of the Roman Republican portraits, like the Etruscan heads, are unidealized, having a veristic quality, or exaggerated realism. The portraits also tend to capture people at older ages, emphasizing the value placed on the elderly, who were appreciated for the wisdom they had acquired through experience.

Roman architects were largely influenced by the Etruscans, who were themselves influenced by the Greeks. Roman cities were built with a regularized layout, especially with regard to the relationship between temples and other buildings around the forum. Systematically arranged cities of the fourth and third centuries B.C., such as Cosa and Ostia, were based on a grid plan, previously seen in Greek cities such as Miletos and Thurii. Roman cities were organized around a major north–south street, the *cardo,* and an east–west street, the *decumanus* (an arrangement that recalls the organization of the Roman *castrum,* the military camp), with the forum, temples, and major public buildings in the center. Domestic architecture from the Republican period also displays an affinity for symmetry and regularity. The houses that were built in Pompeii and Herculaneum as early as the fourth century B.C., preserved as a result of the eruption of Mount Vesuvius in A.D. 79, show the typical layout of rooms around an atrium. The many temples that were built throughout the Roman Republic also reflect influences from the Greek and Etruscan world. Roman temples, like their Etruscan predecessors, were placed on a high podium and had a single entrance. Their facades, as on Greek temples, were decorated with pedimental sculpture.

While the Romans adapted the structures used by the Greeks and the Etruscans, they were innovative in the materials they used and in the introduction of new architectural techniques. For example, Roman architects realized the full economic and structural potential of the true arch, which had been developed by the Greeks in the fourth century B.C. but never put to much use by them. The Romans, on the other hand, used arches extensively in bridges and aqueducts and later for constructing platforms and substructures for large public buildings and houses. They also made

impressive use of new building materials. Their discovery in the third century B.C. that lime mortar poured over rubble produces a concrete of great strength with the capacity to span large areas of space enabled them to construct large-scale buildings. Two of the most characteristic Roman buildings had their origin in the Republican period—the baths and the *basilica,* a large public hall with columns and apses, in which business transactions took place and law courts were held.

The later Republican period, which began about 200 B.C., saw the expansion of Roman power into the Hellenistic kingdoms, but it was riddled with both internal and external strife. From 133 to 31 B.C., when the Republican period ended, the Roman world faced civil conflict. In addition, Social Wars erupted in 90–88 B.C. between Rome and her Italian allies. The victory of Julius Caesar's adopted son Octavian (the later Emperor Augustus) over Antony and Cleopatra at Actium in 31 B.C. signaled the end of the Republican and the start of the Imperial periods. The Julio-Claudian dynasty that he founded would last until A.D. 68. Under Augustus, the Roman Empire entered the *pax romana* (Roman peace), which lasted at home for about two hundred years, during which time the Roman world expanded and vastly increased its wealth. Although this period of peace did not endure, the Roman Empire continued to expand under various emperors until Constantine came to power in A.D. 306.

The beginning of the Imperial period of ancient Rome, in 27 B.C., coincided with the change of Octavian's name to Augustus and the Senate extending him the title of *princeps,* or first citizen. When Augustus came to power, the civil wars were still fresh in public memory. In order to instill a sense of trust in his rule that would ensure the security of Rome, Augustus sought to liken his Rome to the Golden Age of Greece. This is emphasized in the classicizing style of art that was produced during the early Imperial period. Sculpture, especially of the emperors and their families, portrayed them as recognizable but idealized, despite their physical imperfections known from reports by authors such as Suetonius. During the Julio-Claudian period, four main types of imperial statues were produced, which would continue throughout the Imperial period—the *togatus,* garbed in a toga; the *loricatus,* wearing a cuirass; the nude or semi-nude; and the equestrian. Toward the end of the Julio-Claudian dynasty, portraits became more realistic compared with the Augustan classicism, yet they still maintained a degree of softness.

In addition to freestanding sculpture, Roman artists also produced a great deal of relief sculpture to adorn temples, altars, basilicas, arches, and victory monuments. The building programs that had been started during the Republican period were continued under Augustus. Suetonius, in his writings about Augustus, says that he "found Rome a

city of brick and left it a city of marble." The marble came from the quarries at ancient Luna, now Carrara, which, though known earlier, were most fully exploited under Augustus. In addition to the construction of many temples and public buildings, the emperor Tiberius also had a large residence built called the Domus Tiberiana. A few decades later, Nero built the Domus Transitoria, the first great palatial residence in Rome, which was replaced by the Domus Aurea after the great fire in Rome of A.D. 64.

During the Imperial period, wall paintings continued to be used to decorate homes. These paintings have traditionally been divided into four basic styles that are dated between 200 B.C. and A.D. 100. The First Style, also called the masonry style, identifiable by large blocks of color, imitates ashlar masonry. The Second, or architectural, Style incorporates images of realistic architectural elements, such as columns, often opening up the wall with beautiful vistas of landscapes and cityscapes. The Third Style is known as the ornate or candelabrum style. These paintings similarly incorporate architectural elements, which now appear fictive. For example, columns begin to resemble candelabra. The walls of this type have easel-like paintings that typically depict landscapes or figural compositions. The Fourth Style of Roman wall painting is the eclectic intricate or fantastic style, which combines elements of all the previous styles.

The last Julio-Claudian emperor, Nero, left Rome in domestic and external turmoil, which erupted into civil war in A.D. 68–69. The Flavian dynasty that followed lasted until A.D. 96. The Flavian emperors—Vespasian, Titus, and Domitian—returned peace and stability to the Roman Empire. Sculpture made during the rule of Vespasian, A.D. 69–79, tends to recall to a certain degree that of the Republican period, for the emperor wished to associate himself with the virtues of the earlier time. Sculpture of the Flavian period is also identifiable by a baroque quality characterized by dramatic chiaroscuro effects achieved through deep drill-work. Women represented in sculpture, especially the wives of the emperors, mirror the styles established by the emperor. The importance of temporal physical characteristics is reflected also in another group of Roman portraits—Romano-Egyptian mummy portraits from Faiyum, an oasis city that was part of the Hellenistic kingdom of the Ptolemies, which the Romans controlled after the death of Cleopatra in 30 B.C. The Flavians supported architectural programs for the benefit of the citizens of Rome, including the building of the Forum of Vespasian, the Colosseum, the Baths of Titus, and the Domus Flavia.

After the death of Domitian in A.D. 96, the Roman Empire was ruled for eighty-four years by the "Five Good Emperors"—Nerva, Trajan, Hadrian, Antoninus Pius, and Marcus Aurelius. During this time, the Roman Empire's population reached its

maximum number, peace prevailed, and the territory expanded to its farthest boundaries, spanning the territory from the British Isles to North Africa and the Middle East. It ended, however, with a crisis in the Roman state under Marcus Aurelius and his son Commodus. The sculpture of Nerva, who was chosen by the Senate to succeed Domitian, reverts to a classical style, contrasting greatly with the Flavian baroque. The great soldier-emperor Trajan continued to have himself depicted in a similarly classicizing manner, hoping to be seen as the new Augustus. The emperor Hadrian, A.D. 117–138, was a great patron of the arts and a philhellene, or lover of the Greeks. He spent most of his rule traveling throughout his empire to make sure the armies were loyal. Generally unpopular with the Roman aristocracy, he gave up part of the territories Trajan had captured in order to ensure stronger borders. Hadrian's philhellenism is visible in his images, which portray him with a beard—a Greek philosopher-type of image that continued to grow in popularity through the reign of Constantine.

In the second and third centuries A.D., sarcophagi (stone coffins) were widely produced in all parts of the empire. The two main types of sarcophagi are the eastern, which includes the Attic and Asiatic types, and the western. The eastern type is carved on all four sides, while the western is decorated on only three sides, since it was meant to be placed against a wall. The lid on a western sarcophagus is flat with a perpendicular raised edge along the front. Eastern sarcophagi often have gabled roofs or couchlike lids with reclining figures. Both types are often decorated with reliefs depicting mythological scenes.

In A.D. 193, Septimius Severus founded the Severan dynasty, which also included the emperors Caracalla and Severus Alexander, who ruled until A.D. 235. This was a time of great uncertainty with alternating periods of stability and instability. One result was a greater interest in the mystery religions, including the recently founded sect of Christianity, for these cults offered some hope of salvation and a better life after death. This is reflected in the arts by temples built for special mystery cults and by iconographies that show aspects of the cult, such as initiations, as well as images that celebrate the deity of the cults, such as Mithra or Dionysos. Crisis and military anarchy followed the Severans in A.D. 235 and lasted until A.D. 284. Twenty emperors came to power during this period of upheaval. The anxiety of this time is reflected in the portraiture, which captures expressions of trouble. The only major deviation from this "style of crisis" is in the portraits of Gallienus, a philhellene whose Neoplatonic philosophy is captured in his images, which, while still showing expressions of concern and trouble, also reflect a sense of calm.

In A.D. 293, Diocletian established a new form of government, the tetrarchy, which divided the rule of the empire between himself as *augustus* in the East and Maximian as *augustus* in the West, each assisted by a *caesar,* a shift that was necessary in order to quell internal unrest. This autocratic government brought about a loss of personal liberty and the implementation of heavy taxes and price controls that enabled a return to political and economic stability. Images of the tetrarchs are very distinctive in that they are highly stylized with a loss of naturalism. They are represented as blocklike, with large eyes and rigid features.

Although the tetrarchy returned a degree of peace to the Roman Empire, it did not last long, for from A.D. 305 to 324, following the retirement of Diocletian and his counterpart, Maximian, another period of civil war raged. After a long struggle, the last Roman emperor, Constantine the Great, became sole ruler of the empire in A.D. 324 and, in a dramatic shift of the center of power, moved the capital of the Roman world to Constantinople. In 313, he had made Christianity the official state religion. Some say that his support of Christianity is reflected in his portraiture, which shows him with large eyes gazing upward.

The Imperial period of Roman history was one in which the population, the extent of the empire, and both personal and public wealth increased to their greatest point. It was also a time of continuous change and uncertainty. While some emperors ruled during periods of relative peace and prosperity, others were faced with both internal and external wars brought on by the expansion of the empire and the movement and growth of other peoples in Europe. The literary and visual arts flourished throughout, however. The influence of classical Greece on the art of the Roman world is pervasive, visible in all media, and in early works as well as in later ones. Patronage was not limited to the emperors and the imperial circle. Rather, many individuals throughout the Roman Empire, who had benefited from its growth and prosperity, commissioned works of art to decorate their homes or to dedicate as votive offerings.

In the century after Constantine, the Roman Empire was again split into an eastern and a western part. The latter was plagued by numerous invasions by barbarian tribes, while in the East, the Byzantine Empire was taking root. Although there were many political, religious, and social changes during the late Antique period, artistic endeavors continued, maintaining a close reliance on previous styles and subject matter, but gradually changing their motifs and their manner of representation. The Roman Empire was eventually dissolved, but its visual arts continued to have a great impact on those of later periods, including our own.

Portrait of Sulla (?)
Asia Minor, bronze,
first century B.C.

Height: 29.5 cm (11½ in.)
73.AB.8

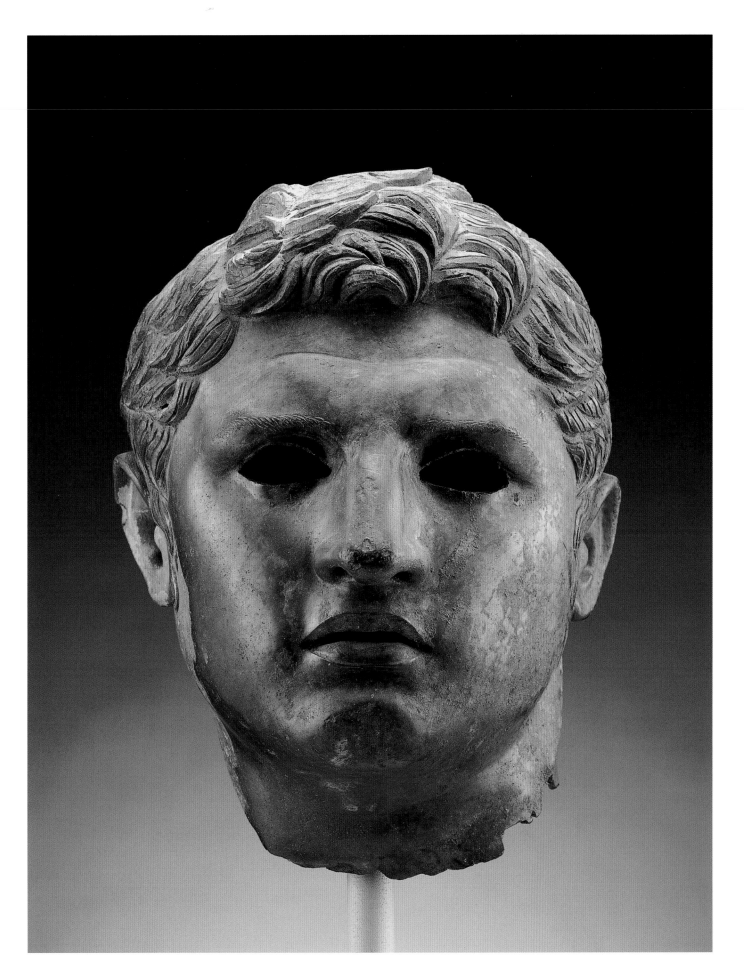

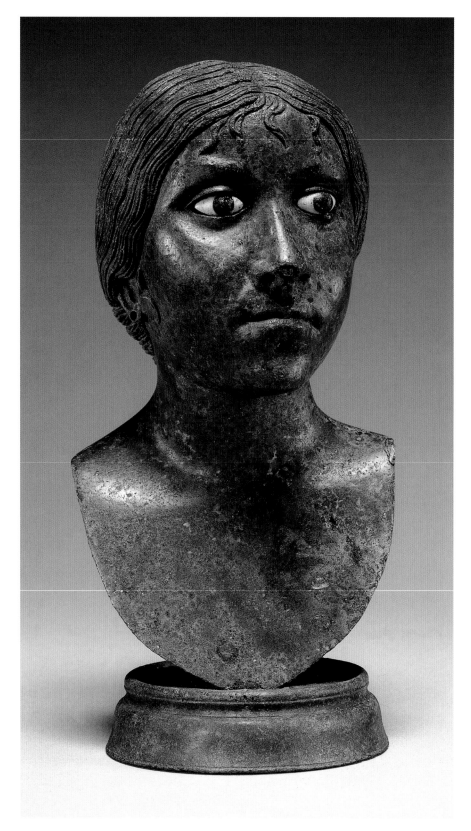

Miniature Portrait Bust of a Young Woman
Rome, bronze with glass eyes,
late first century B.C.

Height: 16.5 cm (6⁷⁄₁₆ in.)
Diameter (base): 6.7 cm (2⁵⁄₈ in.)
84.AB.59

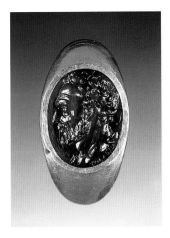

Gem Inset into a Ring Engraved with the Head of Demosthenes
Rome, carnelian and gold, first century B.C.

Gem: 19 x 15 mm (¾ x ⅝ in.)
Signed by Apelles (as gem cutter)
90.AN.13

Portrait Bust of Demosthenes
Rome, bronze, first century B.C.

Height: 7.9 cm (3⅛ in.)
Width: 3.4 cm (1⁵⁄₁₆ in.)
92.AB.105

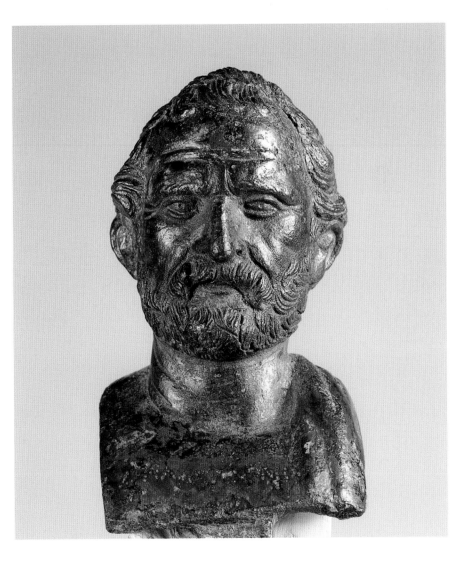

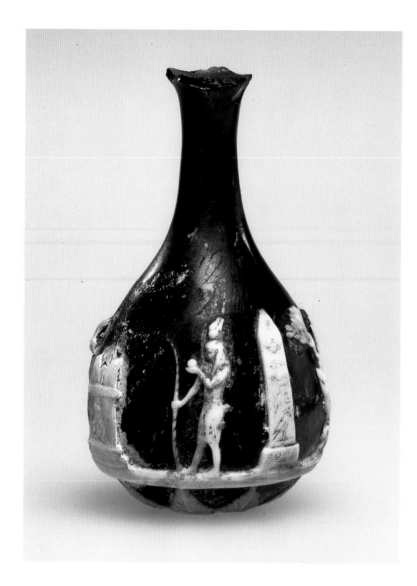

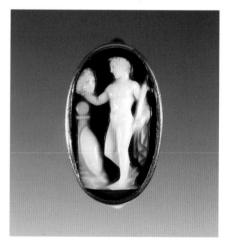

Flask with a Frieze of a Boy with a Garland Approaching an Altar with
the God Thoth as a Baboon on Top, Another Boy before an Altar,
and a Pharaoh with an Obelisk behind Him
Rome, cameo glass (white on blue), 25 B.C.–A.D. 25

Height: 7.6 cm (3 in.)
85.AF.84

Cameo Gem Set into a Ring Showing Perseus
Holding the Head of Medusa
Sardonyx (white on brown), and gold,
25 B.C. – A.D. 25

Diameter (greatest): 20.6 mm (¹³⁄₁₆ in.)
87.AN.24

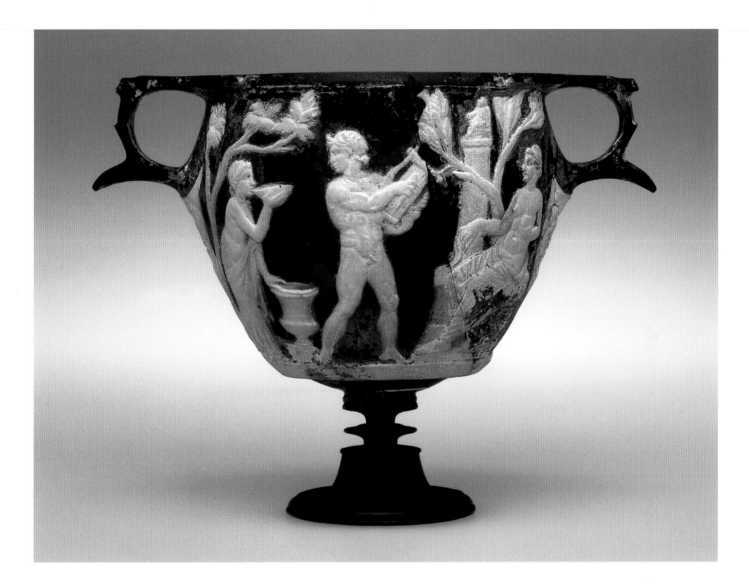

Skyphos Showing a Young Satyr with a Syrinx before a Seated Woman (side A);
Young Satyr with a Lyre between Two Women (side B)
Rome, cameo glass (white on blue), 25 B.C. – A.D. 25

Height: 10.5 cm (4⅛ in.)
Width: 17.6 cm (6⅞ in.)
84.AF.85

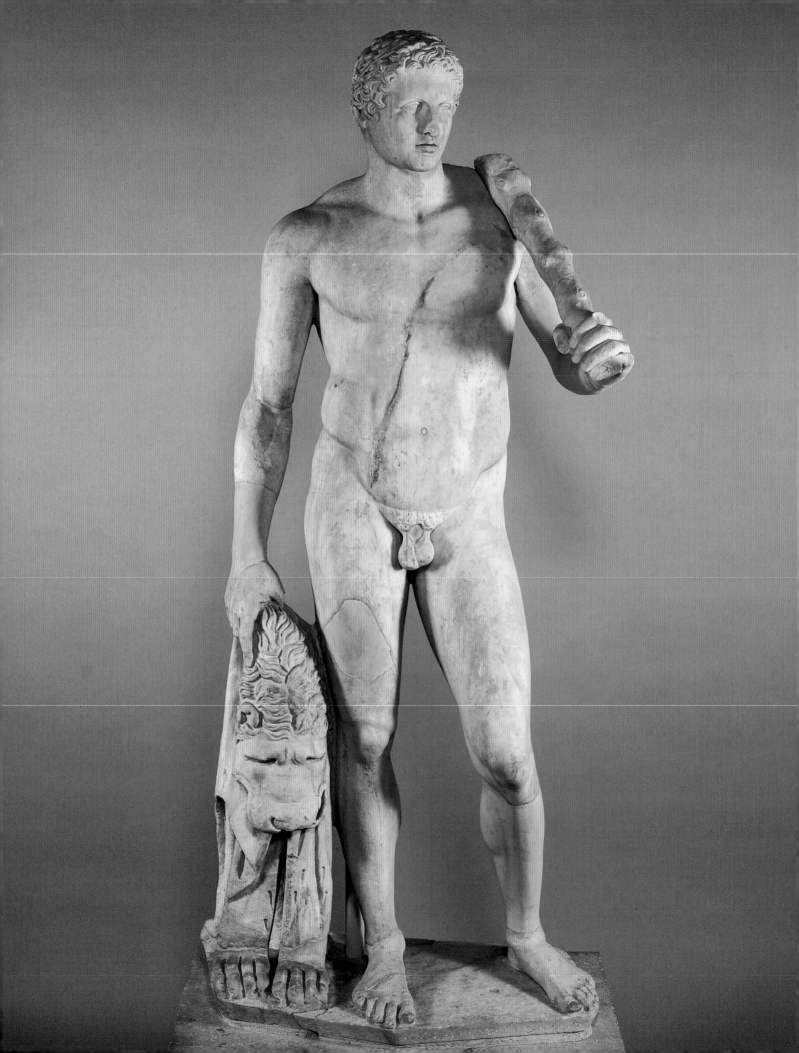

Lansdowne Herakles
Roman copy after a Greek original of the
fourth century B.C., Pentelic marble,
about A.D. 125

Height: 193.5 cm (75½ in.)
Original possibly by Skopas
70.AA.109

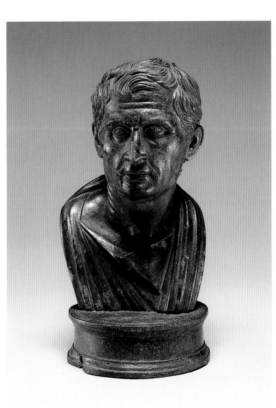

Portrait Bust of Menander
Italy, bronze, early first century A.D.

Height: 17 cm (6⅝ in.)
72.AB.108

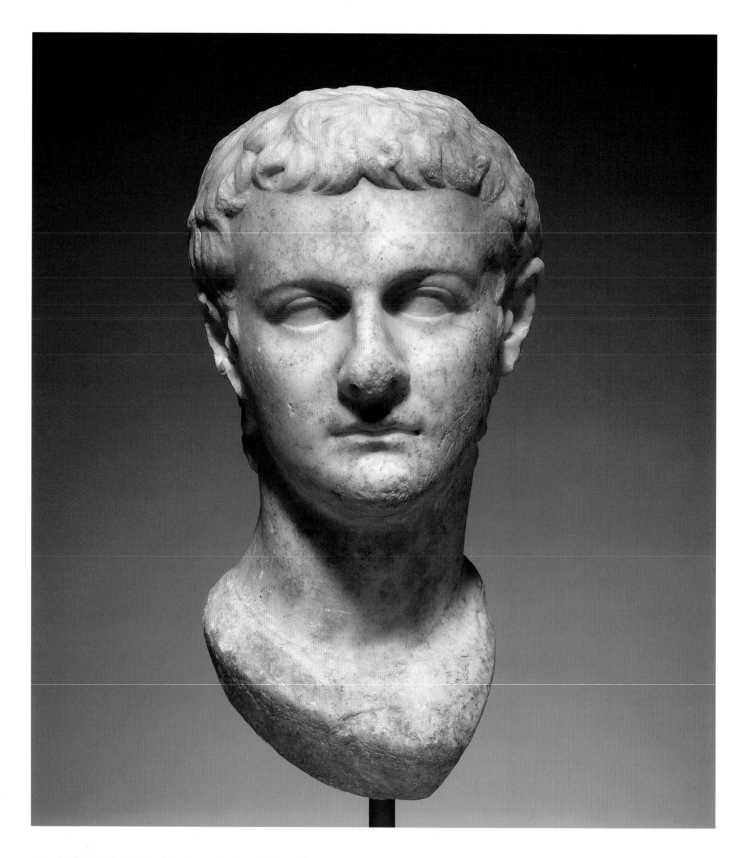

Head of Caligula Worked for Insertion into *Togatus* Statue
Thasian (?) marble, early first century A.D.

Height: 43 cm (16¾ in.)
72.AA.155

Thymiaterion in the Form of a Comic Actor Seated on an Altar
Rome, bronze with silver inlays, first half of first century A.D.

Height: 23.3 cm (9⅛ in.)
Width (base with feet): 13.3 cm (6 in.)
87.AC.143

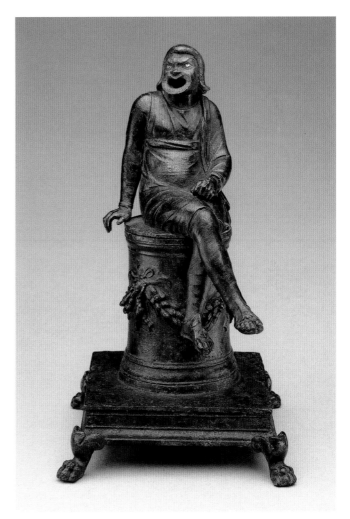

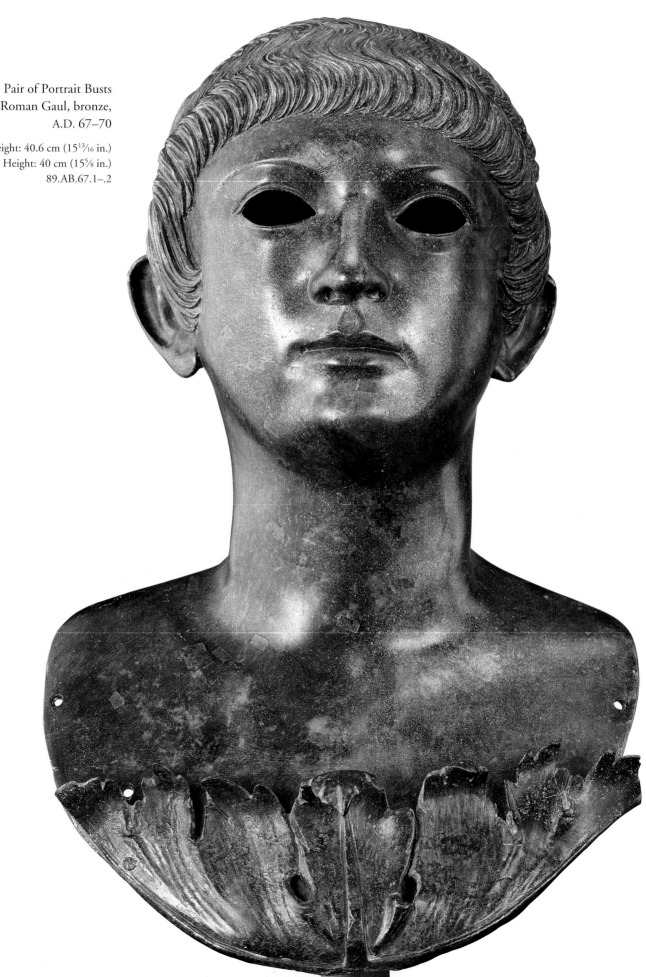

Pair of Portrait Busts
Roman Gaul, bronze,
A.D. 67–70

Height: 40.6 cm (15¹³⁄₁₆ in.)
Height: 40 cm (15⅝ in.)
89.AB.67.1–.2

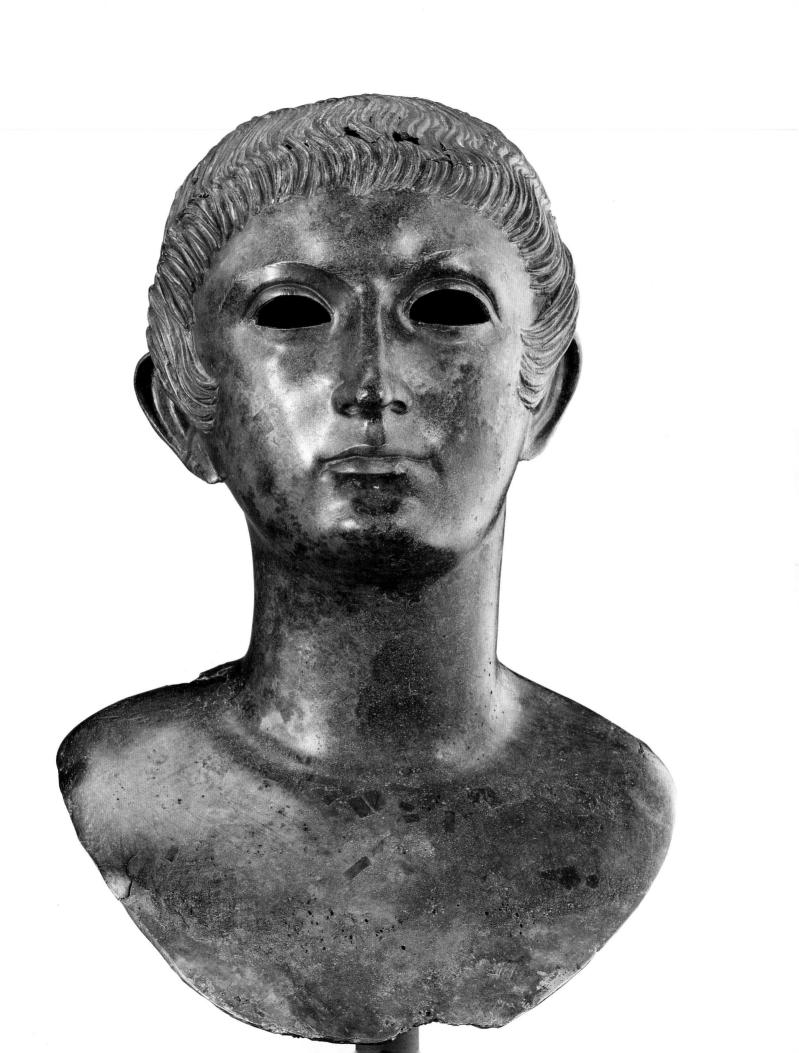

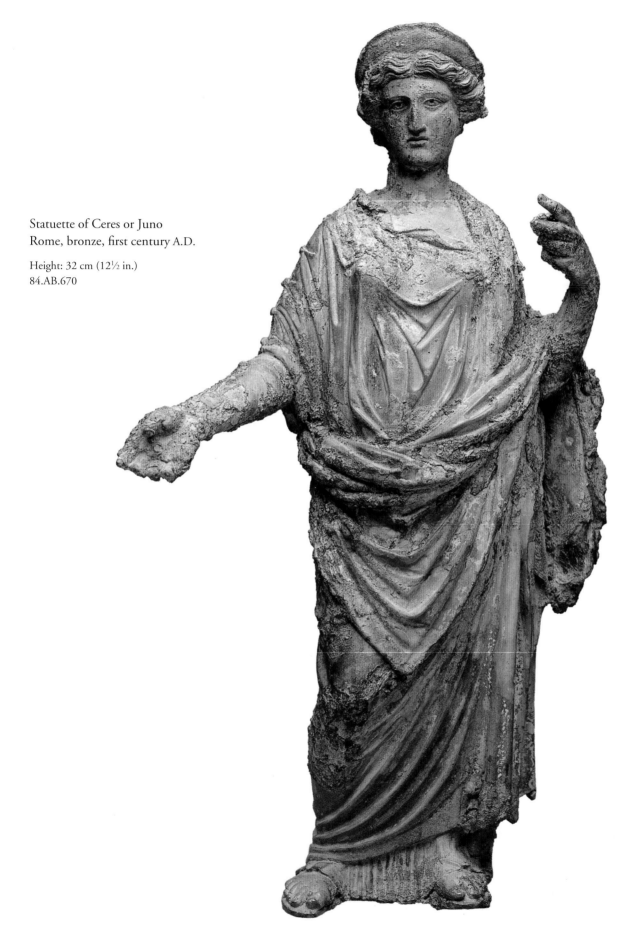

Statuette of Ceres or Juno
Rome, bronze, first century A.D.

Height: 32 cm (12½ in.)
84.AB.670

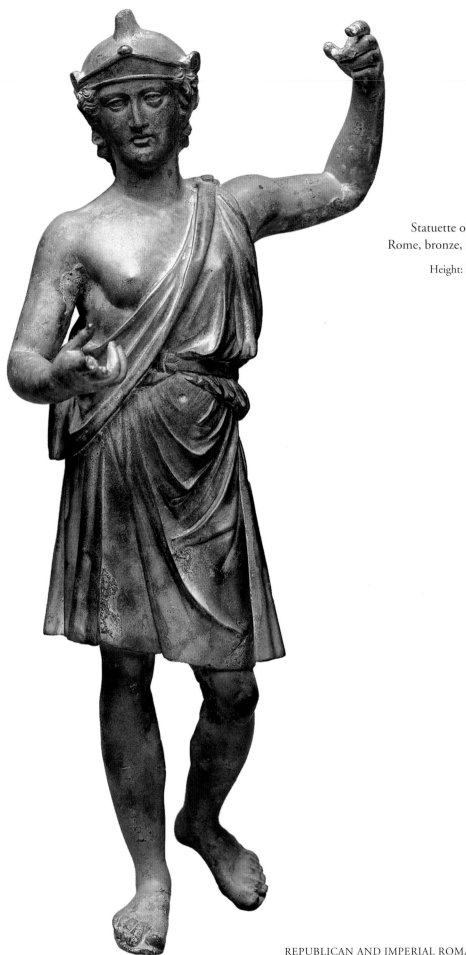

Statuette of Roma or Virtus
Rome, bronze, first century A.D.

Height: 33.1 cm (12^{15}⁄$_{16}$ in.)
84.AB.671

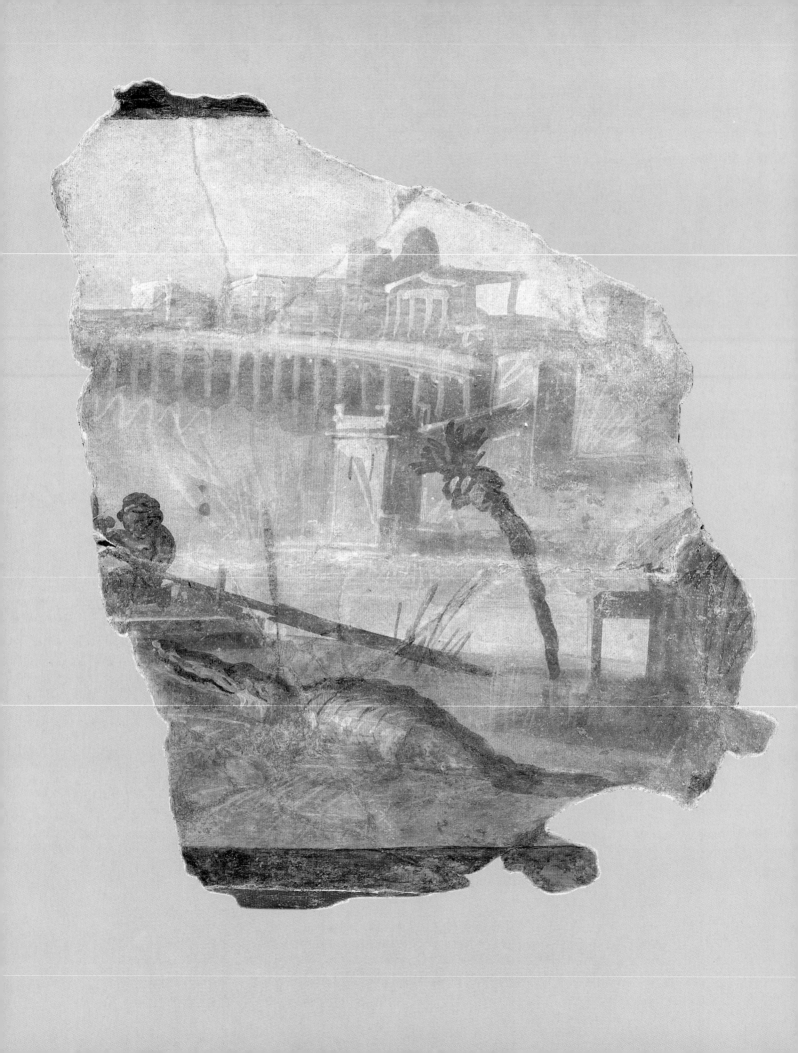

Fresco Fragment with Nilotic Landscape
Italy, tempera on plaster, about A.D. 70

Height: 45.7 cm (17¹³⁄₁₆ in.)
Width: 38 cm (14¹³⁄₁₆ in.)
72.AG.86

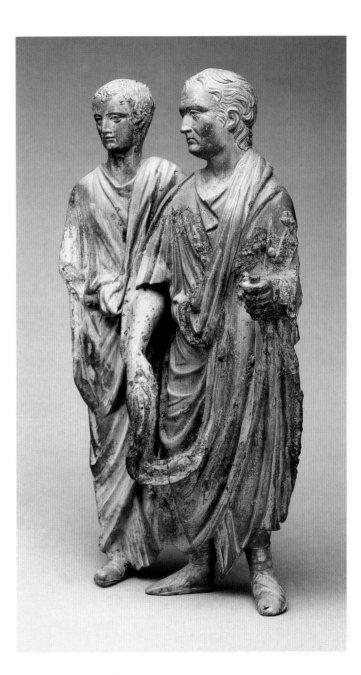

Two Togate Magistrates
Rome, bronze, A.D. 40–68

Height: 26 cm (10⅛ in.)
Width: 13.8 cm (5⅜ in.)
85.AB.109

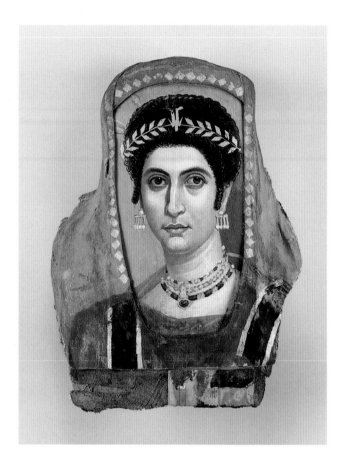

Mummy Portrait of a Woman
Egypt (Faiyum), encaustic and gilt on a wooden panel
wrapped in linen, A.D. 100–125

Height: 33.6 cm (13⅛ in.)
Width: 17.2 cm (6¾ in.)
Attributed to the Isidora Master
81.AP.42

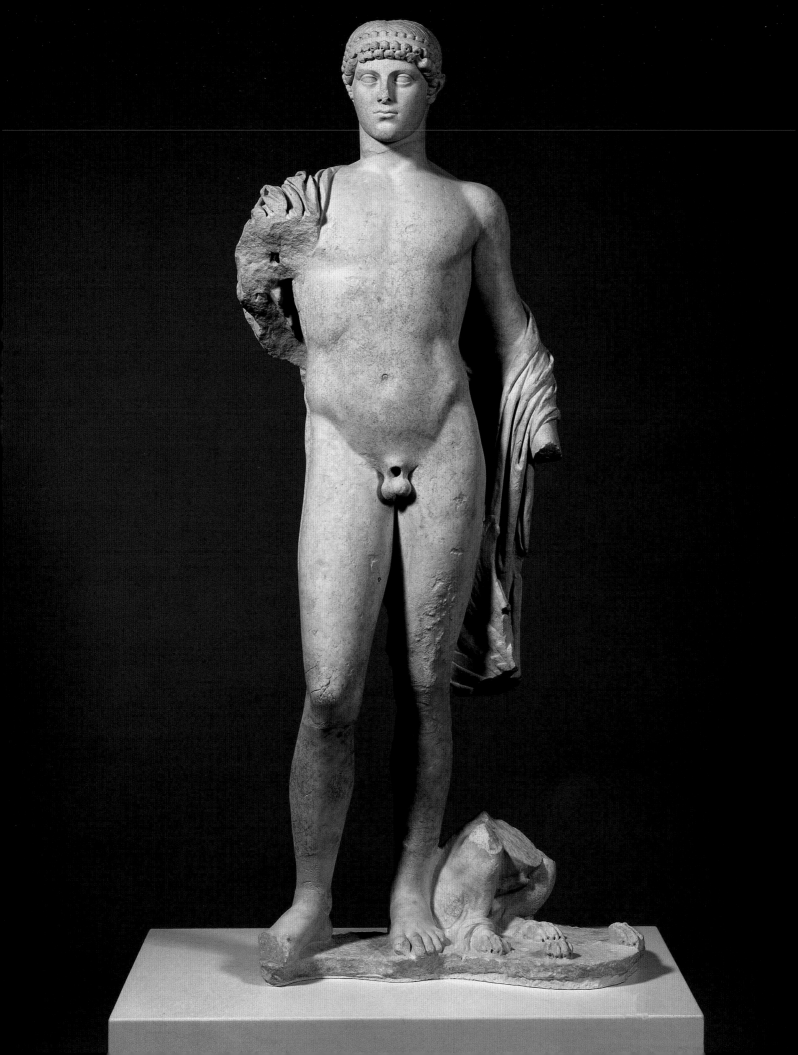

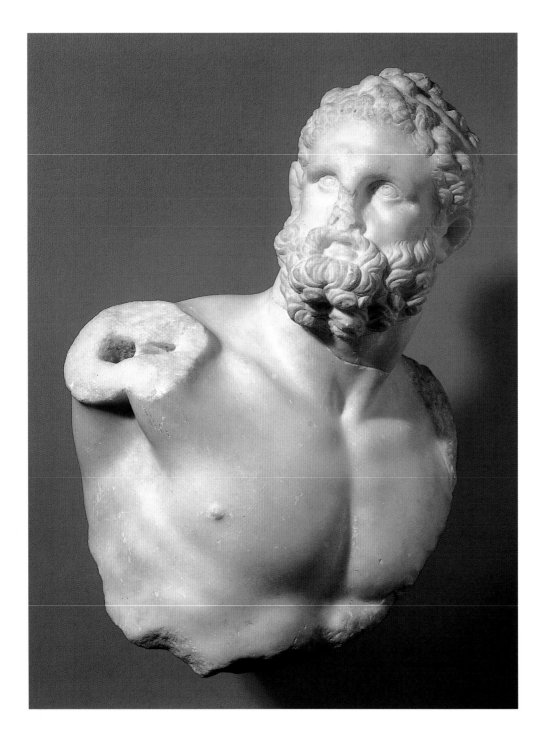

Bust of a Pugilist (Herakles?)
Egypt (Alexandria), Parian marble, second century A.D.

Height: 58 cm (22⁵⁄₈ in.)
Width: 39.5 cm (15⁷⁄₁₆ in.)
83.AA.11

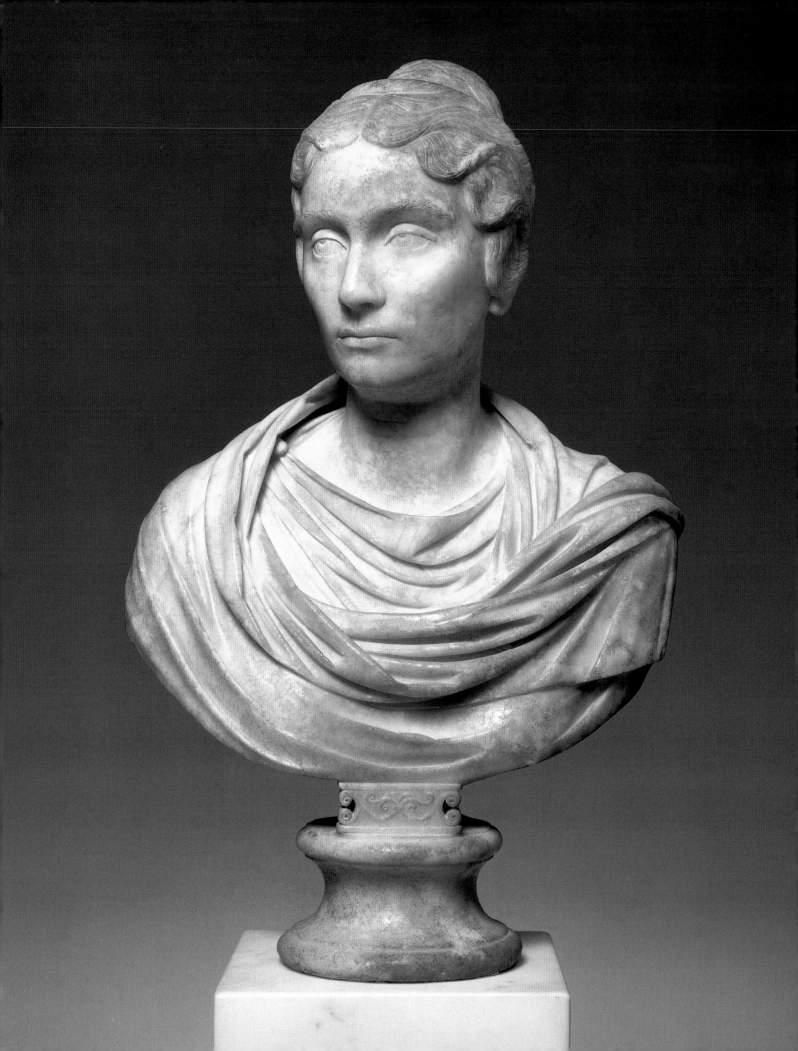

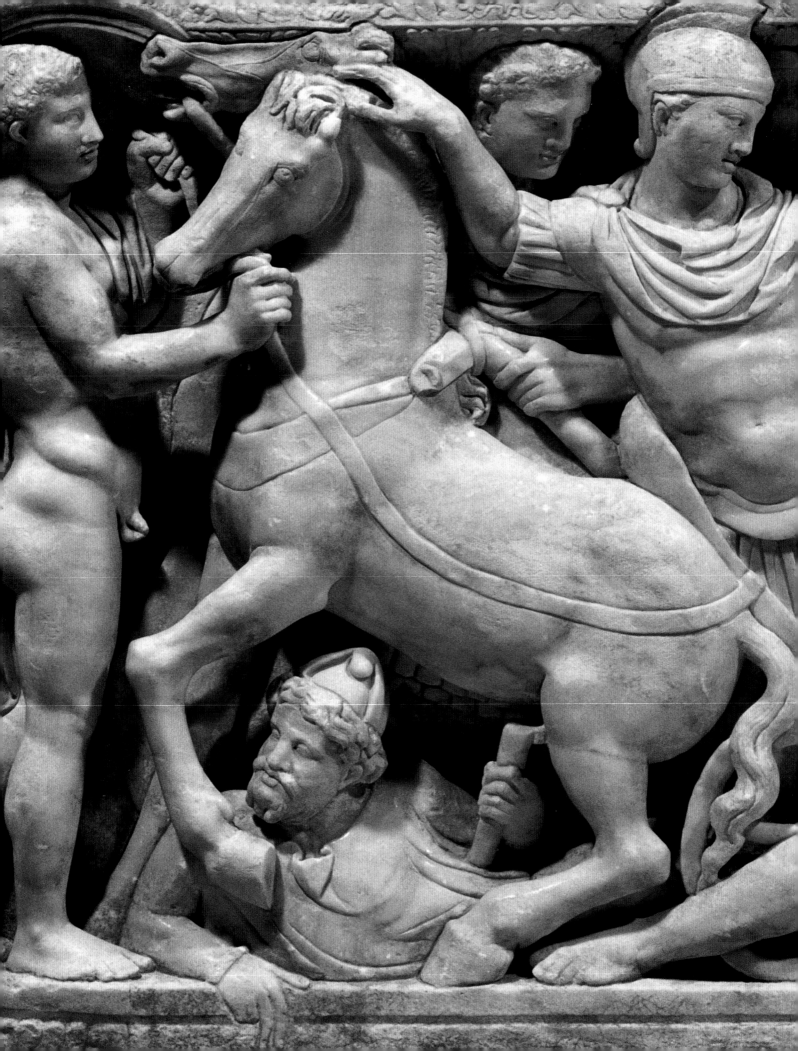

Sarcophagus Showing Achilles Dragging Hector's Body (front);
the Arming of Achilles (end); Centauromachy (back); and the
Discovery of Achilles on Skyros (end)
Marble, late second–early third century A.D.

Length (box): 249 cm (98 in.)
Height (box): 134 cm (53 in.)
Length (lid): 218 cm (86 in.)
Height (lid): 100 cm (39½ in.)
95.AA.80

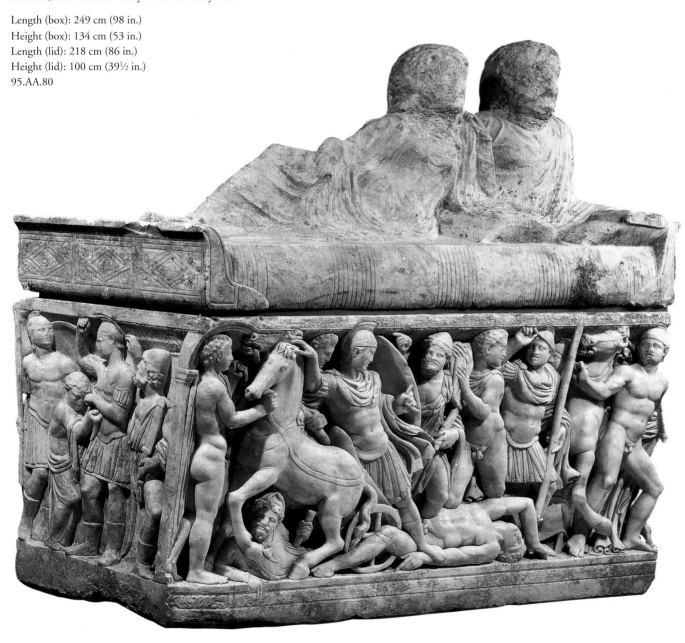

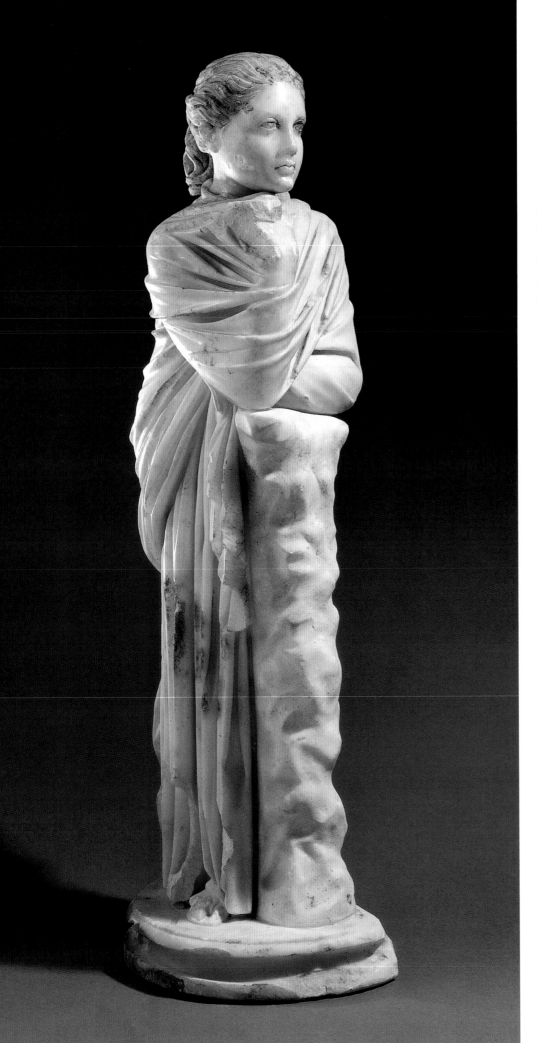

Statue of a Muse, Melpomene
or Polyhymnia
Turkey (Kremna), marble,
about A.D. 200

Height: 97 cm (37¹³/₁₆ in.)
94.AA.22

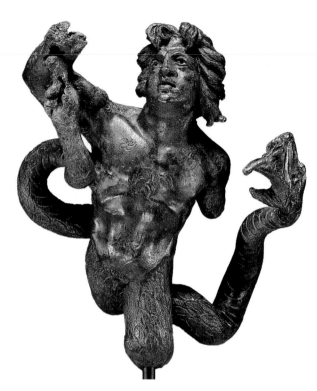

Statuette of a Giant with Legs Modeled as Snakes
Asia Minor (?), bronze,
late second–early third century A.D.

Height: 14 cm (5½ in.)
Width: 12.5 cm (4⅞ in.)
92.AB.11

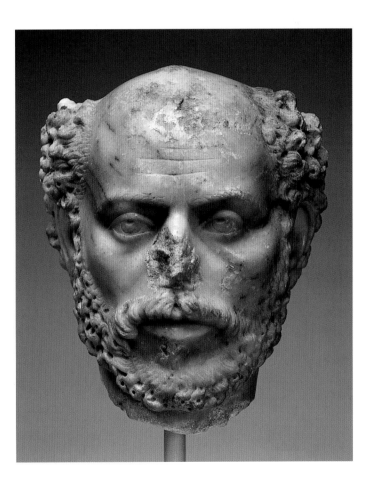

Portrait Head of a Balding Man
Asia Minor, Proconessian marble, about A.D. 240

Height: 25.5 cm (10 in.)
85.AA.112

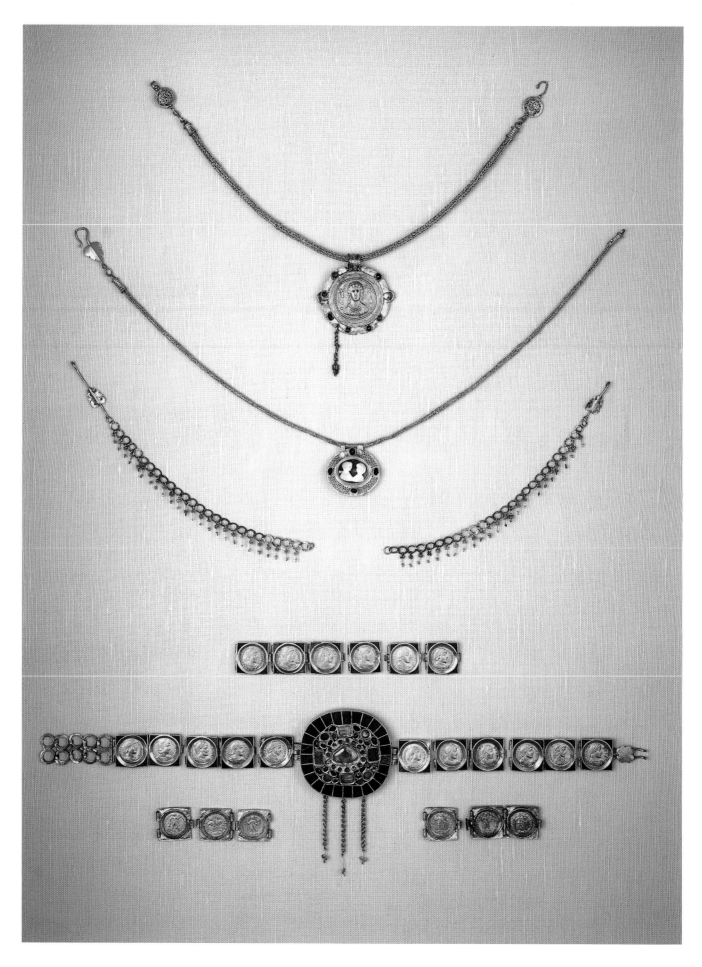

Part of a Roman Hoard of Gold Jewelry
Late fourth–early fifth century A.D.

Necklace with Circular Pendant with inlaid garnets and green and blue glass
Diameter (pendant): 6.3 x 5.4 cm (2½ x 2⅛ in.)
83.AM.225.1

Necklace with Cameo Pendant framed by a setting inlaid with garnets
Diameter (pendant): 4.2 x 3.8 cm (1¹¹⁄₁₆ x 1½ in.)
83.AM.225.2

Two Chains with Pendants
Lengths: 23 cm and 24.5 cm (9 in. and 9⅝ in.)
83.AM.226.1–.2

Belt with Mounted Coins and Central Ornament inlaid with green glass,
emeralds, garnets, and cabochon Ceylon sapphire
Maximum diameter (central ornament): 7.5 cm (2¹⁵⁄₁₆ in.)
83.AM.224 and 86.AM.531

Plate with Relief Decoration of a Fisherman
Byzantium, silver with gilding,
sixth century A.D.

Diameter: 60 cm (23⅜ in.)
83.AM.347

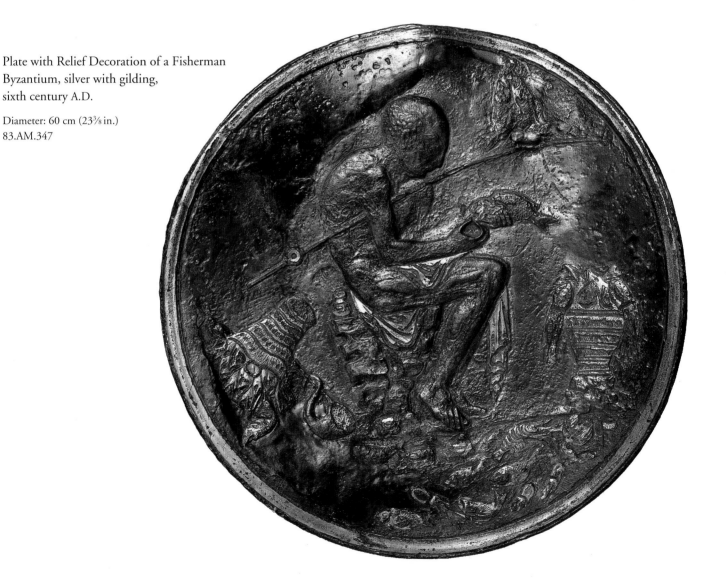

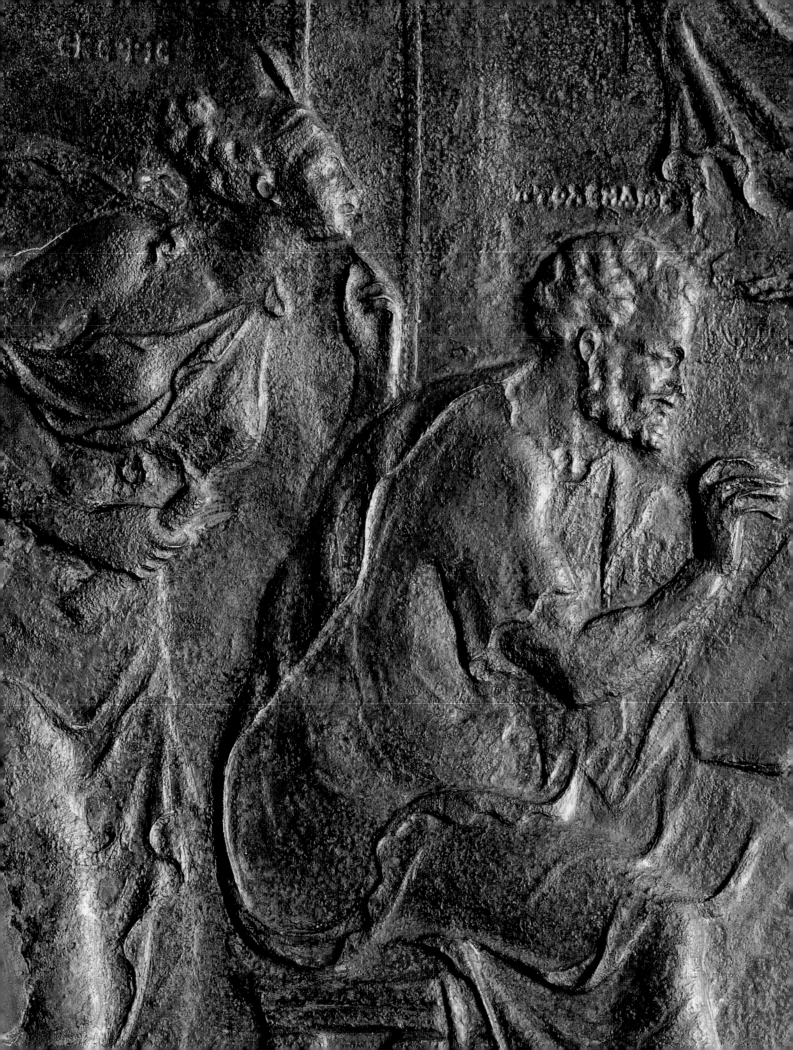

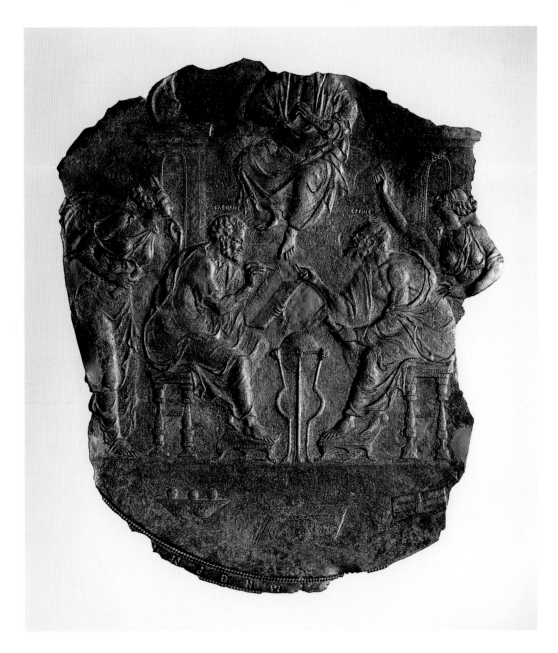

Plate with Relief Decoration of Ptolemaios and Hermes Trismegistos in a Philosophical Discussion
Byzantium, silver, sixth century A.D.

Size: 45 x 28 cm (17⁹/₁₆ x 10⅞ in.)
83.AM.342